Study Guide

Gardner's Art Through the Ages
A Global History

THIRTEENTH EDITION
Volume 2

Fred S. Kleiner
Boston University

Prepared by

Kathleen Cohen
San Jose State University

WADSWORTH
CENGAGE Learning

Australia • Brazil • Japan • Korea • Mexico • Singapore • Spain • United Kingdom • United States

ISBN-13: 978-0-495-50392-7
ISBN-10: 0-495-50392-4

Wadsworth
25 Thomson Place
Boston, MA 02210
USA

Cengage Learning is a leading provider of customized learning solutions with office locations around the globe, including Singapore, the United Kingdom, Australia, Mexico, Brazil, and Japan. Locate your local office at: **international.cengage.com/region**

Cengage Learning products are represented in Canada by Nelson Education, Ltd.

For your course and learning solutions, visit **academic.cengage.com**

Purchase any of our products at your local college store or at our preferred online store **www.ichapters.com**

Printed in Canada
1 2 3 4 5 6 7 11 10 09 08

Table of Contents

Self Quizzes

Preface

This Study Guide accompanies Volume II of *Gardner's Art through the Ages* and is intended to help you assimilate the information that you will encounter as you read the text. The Study Guide contains the following exercises which will enable you to organize and learn the material presented in your art history course:

SHORT ANSWER QUESTIONS: These questions emphasize the basic terminology of art history, important historical individuals, and mythological figures, and important concepts, places, and dates. While many of these questions are factual, others ask you to list stylistic characteristics of particular works or to write the meanings attributed to particular works and to set them within their historical contexts.

DISCUSSION QUESTIONS: Each unit ends with a variety of discussion questions that will help you assess the significance of what you have learned. Some questions are of a general, philosophical nature, requiring reference to specific artists and styles. Some ask for interpretation of theories, sometimes with reference to your daily experience. Others involve the comparison of works, artists, and styles from different times and places. These are calculated to broaden your perspective by asking you to see familiar styles in unfamiliar contexts.

SUMMARY CHARTS: Summary charts are organized chronologically and contain sections for you to fill in with names of major artistic movements or artists, typical examples, stylistic characteristics, and relevant historical information.

SELF-QUIZZES: Self-quizzes appear at the end of the study guide and each one covers multiple chapters of the text. Each quiz contains several images that you have not seen before. You are asked to attribute them to a particular artist or period and give the reasons for your attribution. Answers are given at the back, so that you can determine for yourself how well you are progressing.

If you read the text and complete the exercises in the Study Guide, by the end of the course you should be able to do the following:

1. Define and use common art historical terms.
2. Identify time periods, geographic centers, and stylistic characteristics of major art movements.
3. Identify significant religious concepts, philosophical movements, historical figures, events, and places and discuss their relationship to works of art.
4. Recognize and discuss the iconography popular during various historical periods, as well as the iconography of specific works of art.
5. Set art works in their historical context, comparing and contrasting the reasons why various cultures created works of art as well as the formal characteristics that identify them.
6. Discuss the work of major artists in terms of their artistic concerns and stylistic characteristics, the media they used, and the principal influences upon them.
7. Attribute unfamiliar works of art to particular artists, historical periods, countries, and/or styles.

Many of the questions in the guide will serve as excellent preparation for examinations. Instructors may wish to base some of their examination questions on the materials covered in the guide; they may even wish to establish with students at the beginning of the course that a specified percentage of the examination questions will be taken from the guide.

-Kathleen Cohen, Professor of Art History
San Jose State University

Tips on Becoming a Successful Student

You are starting on an art historical adventure that will enrich your lives. Some of you will do additional studies in art history, but this may be the only art history course that others of you will you take. Whichever path you chose, this course will open the past for you through objects of beauty and power created by men and women from many cultures. You will want to visit the sites of the magnificent buildings you have studied and the museums that house objects you will recognize, as well as many more that you will meet for the first time. These visits will continue to enrich your life.

Your instructor's lectures, the textbook, and the Study Guide all reinforce each other. As you proceed with your study you will learn new study techniques that will further enhance your learning. The section below outlines a number of strategies that successful students use. Try them out and see which work best for you.

ACTIVELY LISTENING TO LECTURES:
During your professor's lectures you will have the opportunity to see large projected images of beautiful works of art, to hear when and why they were created, and to learn what they meant to the people for whom they were made. Your professor's lectures are extremely important both in learning the material and in discovering what he or she feels is most important for you to learn. Pay careful attention to the course syllabus, checking to see the order in which topics will be covered, for you will find that you get more out of the lectures if you have read the relevant material in your text book before coming to class.

It is very important to learn how to keep your mind focused on what the instructor is saying and not succumb to the warm darkness that surrounds you or to let your mind wander. Taking notes on what the lecturer is saying as well as drawing sketches of the projected art works not only imprints the material in your mind, but also helps to keep your mind focused.

You should start with a general title for the lecture and the date. Good students create a different paragraph for each work the teacher presents, headed by the artist, the title and the date. If it is a work of architecture, they include the location. On the left leave a space to draw a simple sketch. It need not be elaborate or even competent, but will serve to help you visualize the work. Then write down a few phrases that the teacher says about the significance of the work and its stylistic characteristics. You should underline the information that the teacher emphasizes.

When you look at your notes in the light, you may find that they are sloppy and hard to read, but nevertheless they are important. Rewriting them after class will further imprint the information in your mind and will provide you with material for integrating into your summary charts as you prepare for examinations. You should star the works from the lecture that also appear in the text, for you will probably want to focus your study on these works.

Sample Lecture notes:

**S Apollinare Nuovo, Ravenna. c. 504 <u>6th c</u> <u>Early Byz</u>

Theodoric patron. 3 aisle <u>basilica</u> form w/<u>arcade</u>. raised beam. wood ceiling, <u>Mosaics</u> above arcade & windows. <u>Processions</u>; prophets <u>Christ life</u>; beardless Christ wears purple. Flattened figures; <u>gold background</u>.

The abbreviations above will tell you that the teacher is most interested in you recognizing the work as Early Byzantine, done in the 6th century, that it is a basilica with an arcade (later you might look up arcade and define it if you don't know). It is decorated mosaics with processions and scenes from Christ's life. Gold backgrounds are typical and the figures are somewhat flattened. You have also noted by the two stars that the book is illustrated in the text. As you can see, the sketch is rudimentary, but it will help recall the image to your mind. (I should confess that when I was an undergraduate, my painting teacher said "If you have to paint, do, but if you can do anything else, do that!" Needless to say, I was crushed, but I think I have been a better art historian than I would have been a painter.) The point is, you don't have to be an artist to make little sketches of the works shown in class, and they will help you learn. You might want to leave a space after each image in your lecture notes to incorporate specific information from the textbook.

READING THE TEXT:
The text will reinforce the instructor's lectures and provide additional background in many areas. Whenever you run across a term that you don't understand, either in the reading or the lectures, look it up in the glossary in the back of the book. You can use the glossary to check spelling and pronunciation. The textbook also includes a guide to the pronunciation of artist's names, which can be very helpful. The notes and bibliography for each chapter provide excellent resources for assembling your bibliography for a research assignment. Each chapter contains a map at the beginning and a chronology at the end. Use these as resources when you are filling out the Study Guide.

FILLING OUT THE STUDY GUIDE:

The Study Guide provides the place to write and to synthesize. Filling out the exercises in the Study Guide will contribute a great deal to your success in mastering the class material. Research has shown that the act of writing down a fact or idea rather than merely reading it serves to imprint it more securely in your mind. Furthermore, reading through the text for specific answers will help you concentrate. With the exception of the lists of definitions or identifications and the Discussion Questions at the end of each chapter, the questions follow the order of the text, so keep your study guide beside you as you read. Fill out these questions as you read though your text and use both its glossary and index to find any terms that you may have missed, as well as the terms and names found in the Definition/Identification questions.

You can use the text or sketches you made from your instructor's lectures as the basis for the sketches requested in the guide. Don't worry if your sketches are awkward; it is the idea that counts. It is also important to know that most people have better visual than verbal memories, and you are more apt to retain the image from your little sketches than from a written description. The maps are another type of visual shorthand, and they will help you put the art works in context and see which works are most closely related geographically. Use the maps in your text to locate the sites requested in the guide.

ABOUT LEARNING DATES:

Students tend to be most apprehensive about how many dates they are expected to learn in Art History classes. Some instructors put much greater emphasis on learning dates than do others. My recommendation is to learn a structure for dates–patterns–rather than trying to memorize many individual dates. The guide asks you to complete a chronology for various sections. The request to write dates in the guide is to help you organize a structure, to create a scaffolding on which you can hang events, art styles, and artists. The comparative chronologies are intended to help you to see what was going on in various parts of the world at the same time, thus creating another type of structure. We learn patterns better than isolated facts, and it becomes easier and easier to connect facts once you have established the chronological structure, the basic pattern.

You should not attempt to memorize all the dates for the various periods, but the mere act of writing them down will help you create your mental structure. For the early periods think in terms of millennia, for later materials in terms of centuries, and for recent materials you might want to think in terms of quarter centuries. Often you need to learn only a few significant dates, and then organize various materials either around that date, before or after it. You will not be too far off you know that the High Renaissance was roughly the first quarter of the 16th century, with Leonardo starting work a bit earlier and Michelangelo

continuing to work later. Sometimes a particular artistic event can help you determine the approximate date of an art work: two that come to mind are the invention of contrapposto in Greece in the early 5th century BCE and of linear perspective in Italy about 1425. Works that contain those characteristics must therefore be after the relevant date. You can often build from what you know to what you don't know if you think and ask yourself questions rather than just trying to memorize a series of dates.

THE DISCUSSION QUESTIONS:

The discussion questions at the end of each chapter are more comprehensive than the more factual questions included earlier, and they are designed to help you integrate what you have learned, make comparisons between the arts of different periods and places, and to speculate about explanations and theories. Your instructor may use them as the basis of discussion in your class, or you may discuss them with students in your study group (see Creating a study Group below). You may also use them as the basis for practice in writing essays (see below).

ESTABLISHING A STUDY GROUP:

Research has shown that students who work with others in study groups generally do better than students who work by themselves. The three elements that you will need to coordinate are 1) locating two to three students who would like to join your group, 2) finding a convenient time and 3) finding a convenient place to get together. If you live on campus in a dormitory 2 and 3 will be easier, but even if yours is essentially a commuting campus you can usually find a quiet place and a convenient time to get together in one of the classrooms that is not in use or in a corner of the student cafeteria. Some students like to get together for an hour before class each week, while others prefer to spend an evening every week or every two weeks. You instructor will probably give you a minute or two at the end of class to identify other students who might be interested in forming a group with you or groups of their own.

Activities at group meetings can vary. The discussion questions in the study guide can serve as an excellent focus for your group, with different students assigned to prepare to lead the group in discussion of specific questions each week. Each student might be responsible for preparing a specific number of image cards that can be used by the group to quiz each other.

SUMMARY CHARTS:

Among the most important aspects of the Study Guide are the Summary Charts included throughout the guide. It is here that you integrate the various things that you have learned from the lectures, your reading of the text, films you have seen, CD and Internet study and the work you have done in the guide itself. As I noted above, we remember patterns much better than individual items, and filling out the Summary Charts creates patterns in your head as well as on paper, for the activity forces you to organize and relate things to each other. Filling out the Chronology Charts as well as the map sections will help you understand how works of art relate to each other in both time and space. And actively filing in the chart is much more effective than merely reading a summary that someone else has prepared. You will probably find this method of studying so effective that you will create your own summary charts for other courses.

STUDYING FOR EXAMINATIONS:

The self-quizzes included in the Study Guide can be a great help in preparing you for course examinations as well as in letting you know how well you are progressing. The quizzes include types of questions often asked in art history examinations: matching, multiple choice, chronology exercises and attribution of unknown images. The guide itself contains other types of questions that are also commonly used: fill-ins, short answer, definitions, and essay questions. If you fill out the Study Guide as you go along, and fill out the summary sheets and take the self-quizzes included in each section before examinations, you will find that you will not need to "cram" the night before. While "cramming" can put things into short-term memory, it is not an effective way to learn. Exercises done over an extended period of time put things into your long-term memory where they have a much better chance of being retained. The best students study as they go along; they will have completed their review and might go to a movie on the night before the examination while their classmates are staying up all night trying to re-read the text and make out the scribblings in their lecture notes.

ADDITIONAL RESOURCES:

The publishers of the text have prepared additional resources that will help you learn. A website for the textbook will bring you exercises, quizzes, flashcards of chapter terms with pronunciation, timelines and maps. The CD ArtStudy that came with your textbook is an excellent source which I recommend to you. The interactive the maps and the timelines are fun as well as instructive, for you get to drag and drop site names and art works into their appropriate slots. A number of the chapters have excellent sections on Architectural basics, clearly explaining the principles and giving you a drag-and-drop quiz that can test how well you have learned the principles. There are Internet activities that are linked to websites with images that you can compare, analyze, or just find out about. The On-line Quizzes are excellent and will provide important ways to study for examinations.

Some students like to look up images on the web and download them into their computer notes. An excellent source is http://worldimages.sjsu.edu which has a section devoted to Art History survey material, and you can locate images by looking up the artist or the site on the web using Google or other search tools.

CREATING YOUR OWN CHARTS ,REVIEWING IMAGES & CREATING FLASH CARDS:

You might wish to create a master sheet that includes all the images from your lectures as well as others from the text book that relate to your instructor's lectures. You could type it up or, better yet, put it on a computer so you can make additions as you run across new material you want to incorporate. If you are using a portable computer you might wish to make your class notes directly on the computer, again using abbreviations as you listen to the teacher's lecture, and then fill in additional information afterward. Bringing all of these things together as you create your charts will be a very effective way to study for examinations.

Active involvement with the images themselves by creating image flash cards is an excellent way to review the visual images. Some instructors mount slides in lighted cases while others create web sites with review images. Both of these are useful techniques. However, you can create your own image review by Xeroxing the images in the text, mounting them on 4 x 5 cards, and putting the relevant information on the opposite side. Some students have printed out thumbnail images from web sites and mounted those on their cards. You will learn a great deal just by making the cards, putting on the images, and writing the relevant information on the backs of the cards. However, you can get even more from them by shuffling them and testing yourself to see if you can give the information on the reverse when you look at the pictures. You can try sorting them by style, by chronology, or by medium. You might work with another student, selecting examples to test each other. You might even come up with some interesting card games, in which you win by having four Italian Renaissance sculptures, three Northern Renaissance paintings, and a Baroque palace, for example. Any devices that you can use to engage actively with the material will help you learn!

TAKING THE EXAM:

It is important to be calm when you take the exam. This means checking the date and time of the examination and getting there a little early so that you have a chance to relax before the exam begins. It also means being sure that you have the appropriate type of answer sheet, if one is needed, a sharpened pencil for marking it, appropriate paper for writing an essay, and a pen, as well as backups in case the pencil breaks or the pen runs out of ink. Some of these things may seem trivial, but if you are not prepared, you can be thrown off base. Before you begin, write your name clearly on all your examination materials, including the answer sheet and the various pages you used to write your essay. There is invariably one student who forgets to write his or her name on something of importance, and you don't want it to be you!

Find out if the instructor subtracts for wrong answers or just counts up correct answers. Some instructors do not want you to guess, but others don't care. I always tell students to guess rather than leaving something blank. Your wrong answer may be quite creative and cheer the instructor up. (I still recall the student who identified a Renaissance floor plan as a Mondrian painting!) Whatever you do, read the questions carefully. Also read the DIRECTIONS carefully. I always allow students to select one essay question out of three or four, but every so often there is some poor soul who tries to answer them all, and does them all badly. When you have finished the examination, check to make sure that you have correctly transferred all your answers to the mechanically scored answer sheet, if you have used one as part of your examination, and that all the blanks are filled in. Check again that your name is on everything, turn in your papers, and go home and relax.

WRITING ESSAYS:

Learning how to write clearly and succinctly is one of the most important tasks of your college career, no matter what your major. While some examination questions will be multiple choice, fill in or short answer, most exams will also include at least one essay question. Since many essay questions will either ask you to trace the development of an art form, to compare and contrast the work of two cultures or two artists, or to set particular works within their cultural contexts, the work that you do in your study guide will prepare you to answer them. The summary charts are particularly useful in this regard, for as you fill them out you do the type of summary and synthesis that serves as the basis for answers to many essay questions. Many of the discussion questions in the guide are similar to essay questions that you will find in examinations. The materials you wrote in the summary charts can be extremely useful, for you are asked to list typical examples of the work of each period or artist. Here are the examples you need for your essay. You will most likely be able to include the material you write in the stylistic characteristics column. Look carefully at the essays included

to the answers to the identifications in the self-quizzes at the end of each section of the study guide. You will see how specific examples are cited in the context of generalizations and how both stylistic features and iconography are used to provide attributions to specific cultures and/or artists. For many essays the material that you included in the significant historical people, events and ideas will be highly relevant.

You can practice writing essays by using some of the questions in the guide. First of all, read the question carefully and answer the question that is asked. This is important, for often students will go off on a tangent and not clearly deal with what they are asked. With many questions you are asked to support your generalizations by specific examples. Be sure and do so! It might be helpful to set some time limits for your practice essays so that you can get an idea of how much you will be able to write in 15 minutes or in 30. You could work with members of your study group, perhaps by all tackling the same essay. At the end of a set time you could critique each other's essays, pointing out good points and offering suggestions.

Whatever essay question that you are tackling, first jot down your ideas and then make an outline of your proposed answer, noting which specific examples you will use to support the points you are making. The outline will serve at least two purposes: 1) to organize your thinking and to help you build you essay to answer the question that you were asked, and 2) to let the reader know what points you would have made in case you run out of time. Begin your essay with an introduction noting the subject of your essay. Develop the points that you made in your outline, and then end with an appropriate conclusion. Assume that you are writing for an uninformed reader. Don't omit relevant information because you think that the teacher already knows it; your instructor is interested in what you know, so be sure and make that clear.

One last tip: Even if you are thrown by the questions, don't just walk out and leave a blank paper. Write something!! You may not gain any points, but you won't be any worse off, and you might just come up with something that is worth a point or two.

VISITING A MUSEUM AND ANALYSING A WORK OF ART:
If you are anywhere near a museum, your instructor will probably urge you to visit it and to study and write about one or more works of art you see there. No matter how good a reproduction you can find in your text or on the web, experiencing a real work of art is a different experience, and it is one that your instructor is preparing you for. The first thing that will strike you is the scale of the work; objects that appeared to be the same size in 35mm slides may be only a few inches tall while others may be over 40 feet high.

After you have walked though the collection, select the work you want to write about and look at it very very carefully. If it is a piece of sculpture walk all around it and if it is a painting or graphic go up very close to it and look at the brushstrokes or other marks. Purchase a postcard of the work or make a photograph of it if photography is permitted. There are many different ways to analyze works of art, but here is one scheme which you might want to use.

1. Write down the museum you are visiting, then the name of the work, the artist who created it, the date, the place where it was made, and the size. What technique and what materials did the artist use?

2. Write down why you selected that particular work of art. What made it attractive to you? What sort of emotional reaction did you have to the work?

3. Next describe the subject matter. What is actually represented? Is the work a portrait, a still life, a landscape? Is it a religious or mythological image? Is it telling a story? If so, what is the source of the story? Are there any symbols in the work? What do they mean? What do you think the work meant to the people who created the work?

4. Analyze the formal elements of the work using the terms that you will find later in this chapter: form and composition, line, texture, mass and volume. Study the color, describing the hues the artist used, the value, saturation and intensity of the hues, and whether the artist emphasized contrasting colors or colors that were very close to each other. Consider how the artist organized the forms the so-called design principles of balance, rhythm, proportion, etc. Is there a focal point or do the forms seem randomly placed? Do diagonal lines or verticals and horizontals dominate? Do the forms seem smooth or jagged, regular or irregular, symmetrical or asymmetrical, dynamic or static? Do the forms seem to stay on the surface or recede into the picture space? Is the space shallow or deep? Did the artist use perspective and foreshortening to create recession?

5. Last consider how effectively the artist used the materials and the formal elements to create a particular impression or to illustrate the theme of the work. How successful do you think the artist was?

TIPS ON WRITING A RESEARCH PAPER:

You may be asked to do a research paper, a paper in which you will go into greater depth about a theme or the work of a particular of a particular artist. You will be using a variety of materials written by different scholars either in journals or in books, and you will use your local library as well as on-line sources to locate these materials.

Your instructor may suggest a guide to writing about art that will explain how to go about writing the paper itself and which will explain how to avoid plagiarizing your sources. Your instructor may also have a particular form that he or she wishes you to follow in footnoting your sources and creating your bibliography. Most art historians use the form approved by the College Art Association which you can find at http://www.collegeart.org/caa/publications/AB/ABStyleGuide.html. The style guide is very thorough, covering capitalization, hyphenation and many other details, but of greatest importance for you are the sections containing the appropriate forms to use for quotations, footnotes and bibliographies.

And now it is time to begin your reading of the textbook. Scan the questions below before you start your reading, and then answer the questions and fill in the blanks as appropriate.

Introduction to Volume II

REVIEW OF THE SUBJECTS AND VOCABULARY OF ART HISTORY

If you did the Study Guide for Volume I of the text, you will already have defined most of the following terms. You might want to review them there. If you are only working with Volume II, be sure that you fill out the sections below because you will need the terminology as you proceed.

TERMINOLOGY REVIEW

Use the text and the glossary or go online to find the meaning of the terms as used by art historians and define them in below.

form: an object's shape and structure, either in two dimensions or in three dimensions

composition: how an artist refers to how an artist organizes forms in an artwork, either by placing shapes on a flat surface or by arranging forms in space

medium (pl. media): the material in which an artist works; also in painting, the vehicle that carries the pigment ex: marble, bronze, clay, fresco)

technique: the process artists employ, such as applying paint to canvas w/ a brush, and the distinctive, personal ways they handle materials

hue: property that gives color it's name

value or tonality: the degree of lightness or darkness

1

intensity or saturation: the purity of a color, or its brightness or dullness

space: bounded or boundless "container" of objects

mass: (The term is not in the glossary, so I will put in the definition for you). Mass defines a three-dimensional volume in space.

line: (The term is not in the glossary, so I will put in the definition for you) a series of points moving in space, as contrasted with the use of mass or shape forms. Lines may be thin or thick. A contour line defines the outer shape of an object.

ICONOGRAPHIC REVIEW

1. Identify the role played by each of the following Greek gods and goddesses, and indicate their Roman equivalents.

Aphrodite (Venus) Daughter of Zeus, & a nymph (goddess of springs & woods); goddess of love & beauty

Apollo (Apollo) God of light, & music, & son of Zeus, the young, beautiful Apollo was sometimes identified w/ the sun (Helios / Sol)

Ares (Mars) God of war, Ares was the son of Zeus & Hera, & lover of Aphrodite, father of twin founders of Rome, Romulus & Remus

Artemis (Diana) sister of Apollo, goddess of the hunt, occassionally equated w/ the moon (Selene / Luna)

Athena (Minerva) Goddess of wisdom, & warefare, was a virgin born from the head of Zeus

Demeter (Ceres) Third sister of Zeus, goddess of grain, & agriculture

Eros (Amor or Cupid) the winged child-god of love, son of Aphrodite, & Ares

Hades (Pluto) Lord of the underworld & god of the dead, brother of Zeus & Poseidon, never resided on Mt. Olympus

Hera (Juno) wife & sister of Zeus, goddess of marriage

Hermes (Mercury) son of Zeus & another nymph, fleet-footed messenger of the gods, carried the caduceus, a magical herald's rod

Posidon (Neptune) Lord of the sea, controlled waves, storms, & earthquakes w/ his three-pronged pitchfork (trident)

Zeus (Jupiter) King of the Gods, ruled the sky & allotted the sea to his brother Poseidon & the underworld to his other brother Hades. weapon= thunderbolt

2. Briefly define the following Buddhist names and terms:

school Amitaba (Amida) Buddha of Infinite Light & Life

Bodhisattva "Buddhas-to-be" exemplars of compassion who restrain themselves at the threshold of nirvana to aid others in earning merit & achieving buddhahood.

Buddha Enlightened one - Four Noble Truths → Eightfold Path = Nirvana

school Mahayana "Great Path" emerged around Christian era

Mudra - hand gestures

school Therevada (Hinayana): "Lesser Path", believe in a larger goal than nirvana for an individual, — namely buddhahood for all.

3

3. Briefly define the following Hindu names and terms:

Devi - Great Goddess who takes many forms & has many names. She creates & destroys

Linga - a phallus or cosmic pilar

Samsara - endless cycle of birth, death, & rebirth

Siva - the Destroyer, but, consistent w/ the multiplicity of Hindu belief, also a regenerative force

Vishnu - preserver of the universe, descends to earth to restore balance & assumes different forms

4. List six events from Christ's incarnation and childhood that are commonly portrayed in art:

a. annunciation to Mary
b. visitation
c. nativity
d. Adoration of the Magi
e. presentation in the temple
f. massacre of the innocents

List six events from his public ministry that are commonly portrayed in art:

a. baptism
b. miracles
c. transfiguration
d. calling of matthew
e. Delivery of the keys to peter
f. cleansing of the temple

What is mean by Christ's Passion?
cycle of events leading to Jesus' death, Resurrection, & ascent to Heaven

List twelve events from the Passion that are commonly portrayed in art:

a. entry into Jerusalem
b. Last supper
c. agony in the Garden
d. Betrayal & Arrest
e. trials of Jesus
f. Flagellation
g. carrying of the cross
h. raising of the cross
i. crucifixion
k. Deposition
l. Lamentation
m. entombment

4

5. Write the names of the following saints after the appropriate description:
Augustine, Francis of Assisi, George, Jerome, Peter, Stephen.

Has a stigmata and wears a long robe, tied at the waist:

Young knight in armor with a cross on his shield:

Carries keys: peter

Scholar at his desk or a hermit in the wilderness:

Holds a stone:

Wears a bishop's vestments and mitre:

ARCHITECTURAL REVIEW
Using the text and the glossary, define the following terms as they apply to
architecture. You may draw diagrams if you wish.

apse

barrel vault

dome

elevation

engaged column

5

entablature

groin vault

keystone

nave

pendentive

plan

section

transept

19
ITALY, 1200 TO 1400

TEXT PAGES 496-517

THE 13TH CENTURY

1. Name one element in Nicola's pulpit in the Pisa Baptistery(FIG. 19-2) that shows the medieval tradition:

 Name one element that shows the influence of classical antiquity:

2. List two characteristics of the Italo-Byzantine style (*maniera greca*):
 a.

 b.

 Name an Italian painter who worked in the style:

3. Who was St. Francis?

 What was the *stigmata*?

4. Name two mendicant orders:

 Describe the influence they had on church architecture.

5. Although Cimabue was deeply influenced by the Italo-Byzantine style, he moved beyond it in the following ways:

 a.

 b.

THE FOURTEETH CENTURY

1. Identify the following:

Black Death

Campanile

Confraternity

Fresco

Grisaille

Humanism

2. What seem to have been the artistic traditions that influenced Giotto and contributed to the shaping of his style?

List two characteristics of Giotto's style as seen by comparing his *Madonna Enthroned* (FIG. 19-8) with Cimabue's version of the same subject (FIG. 19-7).

a.

b.

Giotto created a great fresco cycle in the _____chapel in _____. It was consecrated in the year _____.
The subjects of the framed scenes deal with:

List four characteristics of Giotto's style as seen in the *Lamentation* scene (FIG. 19-9).

 a.

 b.

 c.

 d.

3. The subject of Duccio's *Maesta* (FIGS. 19-10 and 19-11) was :

List three stylistic elements he derived from the Byzantine tradition:

 a.

 b.

 c.

List three ways in which he modified it:

 a.

 b.

 c.

4. How is the façade of Orvieto Cathedral (FIG. 19-12) related to those of French Gothic churches?

5. How did Simone Martini help to form the so-called International style?

List four characteristics of that style.

 a.

 b.

 c.

 d.

6. How were artists trained in Italy during the 14th and 15th centuries?

7. Panoramic views of the city of Siena and its surrounding countryside were painted by _____ in the Palazzo Pubblico in Siena as part of a fresco known as _____ . _____ .

What revolutionary aspects are found in this fresco (FIGS. 19-16 and 19-17)?

8. Florence cathedral was begun under the direction of:

List two features of the interior that add to its sense of spaciousness:

 a.

 b.

9. What historical event seems to be foreshadowed by the subject of *The Triumph of Death* (FIG. 19-20)?

 What message was the iconography most likely intended to convey?

10. What features of the Doge's Palace in Venice can be considered to be Gothic?

11. How do the proportions of Milan Cathedral (FIG. 19-22) compare with those of French Cathedrals like Amiens (FIG. 18-21)

DISCUSSION QUESTIONS

1. Discuss the effects of social and economic changes between the late thirteenth and late fourteenth centuries on Italian art of the period.

2. Compare the versions of the *Nativity* by Nicola and Giovanni Pisano (FIGS. 19-3 and 19-4) with the Late Antique *Ludovisi Battle Sarcophagus* (FIG. 10-70). How are the Pisani works similar to this Roman example? How are they different from it and from each other?

3. Compare Giotto's *Lamentation* (FIG. 19-9) with Duccio's *Betrayal of Jesus* (FIG. 19-11); note particularly the use of space, three-dimensional volume, and the sense of drama.

4. Compare Simone Martini's *Annunciation* (FIG. 19-13) with the *Virgin of Jeanne d'Evreux* (FIG. 18-37). Can you find any stylistic characteristics of the French figure that can be related to those of Simone's version? Discuss the historical factors that account for the French influence in his work.

5. Compare Florence Cathedral (FIGS. 19-18 and 19-19) with Cologne Cathedral (FIGS.18-47 and 18-48) Note especially the way in which decorative details are integrated with the construction as a whole. What design features does Florence Cathedral share with Orvieto Cathedral (FIG. 19-12) and Milan Cathedral (FG. 19-22)?

LOOKING CAREFULLY, DESCRIBING AND ANALYZING

Look carefully at Lorenzetti's *Effects of Good Government* in the city and in the country (FIGS. 19-16 and 19-17) and compare them to the landscape and architectural scenes in on Berlinghieri's *St. Francis* altarpiece (FIG. 19-5). Write a one page essay analyzing each of the images using the following terms: form and composition; material and technique; space, mass and volume, line, and color. Here are some questions that might help you with your analysis, but do not be limited by them. What differences do you see in the artists' approaches to composition and form, particularly in the depiction of space? How does each artist describe architectural forms and the forms of the mountains? In each case how are human figures related to the environment both in scale and position. Which has the greatest sense of space? Which elements contribute to that sense?

11

SUMMARY OF ART & ARCHITECTURE IN ITALY 1200-1400

Fill in as much of the chart as you can from memory. Check your answers against the text and complete the chart. Include additional material supplied by your instructor.

	Typical Examples	Stylistic Characteristics	Significant Historical Events, Ideas, etc.
Nicola Pisano City:			
Giovanni Pisano City:			
Berlinghieri City:			
Duccio City:			
Cimabue City:			
Giotto City:			
Lorenzetti City:			
Traini City:			
Orvieto Cathedral:			
Florence Cathedral:			
Milan Cathedral:			

20
NORTHERN EUROPE 1400 TO 1500

TEXT PAGES 518-539

What type of economic system developed in Europe in the 15th century?

BURGUNDY AND FLANDERS

1. Name the two northern dukes who were great patrons of the arts in the late fourteenth and early fifteenth centuries:

 a. b.

 Where did they establish their capital?

2. Who was the sculptor of the *Well of Moses* at the Chartreuse de Champmol (FIG. 20-2)?

 What was its symbolic meaning?

 List two phrases that describe its style:

 a.

 b.

3. What new feature is seen in Broderlam's wings from the *Retable de Champmol* (FIG. 20-3)?

 Name two medieval conventions he retains:
 a.

 b.

4. Define the following terms:

Eucharist

polyptych

retable

triptych

5.What painting technique was perfected by fifteenth-century Flemish painters?

Briefly describe the technique:

In what respects did it prove superior to the tempera technique?

6. List two factors that contributed to the great demand for images for private devotion:
 a.

 b.

7. What effect did the blending of sacred and secular have upon the way devotional images were painted?

8. What sort of setting did Robert Campin utilize for the *Merode Altarpiece (FIG. 20-4)*?

What did the book, candle, water jug and towels symbolize

List three characteristics of Campin's style:

a.

b.

c.

9. What is the general theme of the *Ghent Altarpiece* (FIGS. 20-5 and 20-6)?

Write the subjects of the various panels in the corresponding spaces below:

What is symbolized by the following in the central panel?

lamb: _____ fountain: _____

What is symbolized by the following groups on the lower wings?

hermits: _____ judges: _____

pilgrims: _____ knights: _____

10. What was the probable purpose of the painting *Giovanni Arnolfini and His Bride* (FIG. 20-1)?

List four symbols contained in the painting and give their meanings:

a.

b.

c.

d.

11. What is new and significant about the pose of the *Man in a Red Turban* (FIG. 20-7)?

12. In contrast to the complex symbolism and optimism of Jan van Eyck, what did Rogier van der Weyden stress in his paintings?

List three characteristics of his style:

a.

b.

c.

13. List the Flemish characteristics of Rogier's *Portrait of a Lady* (FIG. 20-10) that distinguish it from the work of Italian artists such as Ghirlandaio (FIG. 21-25).

a.

b.

c.

14. Describe the role played by the Guild of Saint Luke in the life of the northern painters in the fifteenth century and the way in which a young man attained membership in the guild:

15. How did most women artists receive their training during the fifteenth and sixteenth centuries?

16. Name the two fifteenth-century Flemish painters who demonstrated the greatest interest in the depiction of space and cubic form.

a. b.

17. What is the setting of Christus' painting that is identified with the legend of Saint Eligius (FIG. 20-11)?

Who might have commissioned it?

18. Scholars believe that _____ was the first northern artist to utilize a single vanishing point for construction of an architectural interior.

19. What is the symbolic meaning of the following items in the central panel of the *Portinari Altarpiece* (FIG. 20-13)?

Iris and columbine:

Sheaf of wheat:

Harp of David:

20. In what sort of subject matter did Memling specialize?

Briefly describe his style:

FRENCH ART

1. What is a Book of Hours?

2. Name the artists who illuminated the *Tres Riches Heures du Duc de Berry* shown in FIGS 20-15 and 20-16:

Who was the Duke of Berry?

What is the subject portrayed in the most famous illustrations in the *Tres Riches Heures?*

List three ways in which they embody the new interest in naturalism and the increasing merger of religious and secular concerns:

a.

b.

c.

3. List two features of Fouquet's panel (FIG. 20-17) that are similar to Flemish donor portraits:
a.

b.

Who served as model for the Virgin Mary?

HOLY ROMAN EMPIRE

1. Name two groups of people who were the primary patrons in fifteenth century
 Germany:

 a. b.

2. What subject did Stoss depict in the center of the Krakow altarpiece
 (FIG. 20-18)?

 List three typical Late Gothic characteristics of his style:

 a.

 b.

 c.

3. What mood is most typically expressed in the figures carved by
 Riemenschneider (FIG. 20-19)?

4. List three characteristics of the style of Konrad Witz:

 a.

 b.

 c.

5. Define the following terms associated with graphics:

 burin

 engraving

 etching

intaglio

relief

woodcut

6. What is the *Nuremberg Chronicle*?

What technique was used to produce it?

7. In what medium did Martin Schongauer work?

Briefly characterize his style:

DISCUSSION QUESTIONS

1. Compare Sluter's figure of *Moses* (FIG. 20-2) with Donatello's *Saint Mark* (FIG. 21-5). In what way do the figures typify the concerns of northern and Italian artists.

2. Compare the treatment of the architecture and landscape in the work by the Limbourg Brothers (FIG. 20-16) with that in Ambrogio Lorenzetti's *Effects of Good Government* (FIG. 19-17). In what ways are they similar? In what ways do they differ?

3. Masaccio's *Holy Trinity* fresco (FIG. 21-20) and Campin's *Merode Altarpiece* (FIG. 20-4) were painted about the same time . Compare them from the point of view of scale, medium, and treatment of space. Does Campin use linear perspective? Identify the orthogonals in each and locate the vanishing point, if one exists. How do the two works reflect the different concerns of Italian and northern artists?

4. How does the northern approach to portraiture as shown in Van der Weyden's *Portrait of a Woman* (FIG. 20-10) differ from the approach of Italian portraitists as seen in Ghirlandaio's *Giovanna Tornaboni* (FIG. 21-25)?

5. Discuss the *Portinari Altarpiece* (FIG. 20-13) by Hugo van der Goes; note especially the iconography and the meaning of the disguised symbols. What stylistic influence do you see from Jan van Eyck? How does this altarpiece differ from Van Eyck's *Ghent Altarpiece* (FIG. 20-5 and 20-6)?

6. Compare Schongauer's *Saint Anthony* (FIG. 20-22) with Mantegna's representation of *the Foreshortened Christ* (FIG. 21-49) from the points of view of technique, meaning, and emotional impact. What stylistic devices were used to achieve the differing effects?

7. Compare Rogier van der Weyden's *Deposition* (FIG. 20-8) with a similar subject by Giotto (FIG. 19-9). Which moves you most? Why?

LOOKING CAREFULLY, DESCRIBING AND ANALYZING

Look carefully at the *October* page by the Limbourg brothers from the *Tres Riches Heures du duc de Berry* shown on and in FIG. 20-16) Write at least one page analyzing the image, using the following terms: form and composition; material and technique; space, mass and volume, line, and color. Here are some questions that might help you with your analysis, but do not be limited by them. Describe each object that you see, starting from the bottom of the composition and going to the very top. How do the artists approach the composition? How do they divide the composition and how do they indicate that the space is three dimensional? How do the artists describe architectural and natural forms? How are human figures related to the environment both in scale and position.

SUMMARY OF 15TH CENTURY ARTISTS NETHERLANDS

Fill in as much of the chart as you can from memory. Check your answers against the text and complete the chart. Include additional material supplied by your instructor.

	Typical Examples	Stylistic Characteristics	Significant Historical Events, Ideas, etc.
Sluter			
Broederlam			
Campin			
Van Eyck			
Roger van der Weyden			
Bouts			
Christus			
Van der Goes			
Memling			

SUMMARY OF 15th CENTURY ARTISTS IN FRANCE & HOLY ROMAN EMPIRE

Fill in as much of the chart as you can from memory. Check your answers against the text and complete the chart. Include additional material supplied by your instructor.

	Typical Examples	Stylistic Characteristics	Significant Historical Events, Ideas, etc.
Limbourg Brothers Country:			
Fouquet Country:			
Stoss Country:			
Riemenschneider Country:			
Witz Country:			
Wolgemut Country:			
Schongauer Country:			

21
ITALY 1400-1500

TEXT PAGES 540-577

1. List three tenants that underlay Italian Humanism:

 a.

 b.

 c.

2. What fifteenth-centuryGerman invention facilitated the distribution of books and the knowledge they contained?

3. List four roles played by the arts in 15th century Italian princely courts.

 a.

 b.

 c.

 d.

FLORENCE

1. What was the basis of the wealth of the Medici family?

2. Name the two finalists for the commission of the north doors of the Baptistry of Florence and briefly describe their styles:

 a.

 b.

3. Name the patrons and the artists who created the following figures for Or San Michele:

	Artist	Patron
Saint George:		
Saint Mark:		
Four Crowned Saints:		

4. In what figure did Donatello first utilize the principle of weight shift (*ponderation*)?

Describe *contrapposto*:

5. List three elements that constitute the greatness of Donatello's art,

a.

b.

c.

6. Donatello's *Feast of Herod* (FIG. 21-8), done in 1425, marked the advent of:

7. The invention of linear perspective is generally attributed to:

8. Define the following and draw and label a diagram if appropriate:

Atmospheric perspective:

Linear perspective:

Orthogonals:

Horizon line:

Vanishing point:

9. The artist who created the doors of the Baptistry of Florence Cathedral that best demonstrate the new principles of linear perspective was:

What name did Michelangelo give to the doors?

10. What was the major significance of Donatello's bronze statue of *David* (FIG. 21-12)?

Describe the classical characteristics that are apparent in the figure:

It was commissioned for the courtyard of _____.

11. One of the most important Italian sculptors of the second half of the fifteenth century, who was also a painter, was _____.

 How does his *David* (FIG. 21-13) differ from Donatello's version (FIG. 21-12)?

 a.

 b.

 c.

12. List three adjectives that characterize the effect created by Pollaiuolo's *Hercules and Antaeus* (FIG. 21-14):

 a.

 b.

 c.

 What seems to have been his primary artistic interest?

13. Italian cities commissioned portraits to commemorate famous condottieri. The of the most famous are bronze equestrian figures. List the condottieri, the artist, and the city:

Condottieri	Artist	City
a.		
b.		

14. Gentile da Fabriano's *Adoration of the Magi* (FIG 21-17) is considered a masterpiece of the _____ style.

15. In contrast to Gentile's conservatism, Masaccio's *Tribute Money* (FIG. 21-18) was revolutionary. List three of his innovations:

 a.

 b.

 c.

16. What two Renaissance interests are summed up in Masaccio's *Holy Trinity* fresco (FIG. 21-12)
 a.

 b.

17. The monk who painted a series of devotional frescos in the monastery of San Marco
was:

 Briefly characterize his style:

18. Under the influence of reliefs by Ghiberti and Donatello, Fra Filippo Lippi abandoned a style based on Masaccio's massive forms and developed his mature style, which is characterized by:

19. A secularization of sacred themes can be seen in the portraits of Florentine women as represented in the fresco *The Birth of the Virgin* (FIG 21-25) by_____.

It has been said that the work of Ghirlandaio summed up the state of Florentine painting at the end of the fifteenth century. List three of those achievements:

a.

b.

c.

20. The Florentine artist who combined training in the International Style with a passion for perspective was_____.

21. A literary source for Botticelli's *Birth of Venus* (FIG. 21-27) was _____, while a visual model was _____. Botticelli seems also to have been influenced by the allegorical pageants which appealed to his cultivated patrons.

List three characteristics of Botticelli's style.

a.

b.

c.

22. Why did Brunelleschi design the dome of Florence Cathedral with an ogival rather than a semi-circular section?

23. Which of Brunelleschi's buildings most closely approximates the centralized plan?

Write down three phrases that describe its interior (FIG. 21-134 and 35):

a.

b.

c.

24. Who designed the Palazzo Medici-Riccardi?

The design of the courtyard shows the influence of _____.

What is rusticated stone and how was it used on the Palazzo Medici-Riccardi?

25. Three principles advocated by Leon Battista Alberti in his *De re aedificatoria* were:

a.

b.

c.

26. What feature does the Palazzo Rucellai (FIG. 21-38) share with the Roman Colosseum?

In what way is it markedly different?

27. Which Romanesque church seems to have influenced Alberti when he designed the facade of Santa Maria Novella?

In what way did he modify the Romanesque original to create a highly sophisticated Renaissance design?

28. What effect did the preaching of Savonarola have on the people of Florence?

THE PRINCELY COURTS

1. What was the subject of Perugino's fresco for the Sistine Chapel (FIG. 21-40).

What was its political significance?

How does the work illustrate the principles of linear perspective?

2. In what way could the frescos painted by Signorelli in Orvieto Cathedral (FIG. 21-41) be said to echo Savonarola's sermons?

The text describes Signorelli"s "foreshortening". What does that mean?

3. Piero della Francesca's *Enthroned Madonna and Saints Adored by Federico Montfeltro (Brera Altarpiece)*(FIG. 21-42) was commissioned by _____.

List two devices that Piero used to refer to his patron's dead wife:

a.

b.

List three characteristics of Piero's style as seen in the *Brera Altarpiece* and the *Flagellation of Christ*:

a.

b.

c.

4. List two projects commissioned by Ludovico Gonzaga in Mantua:

a. b.

5. The two Roman architectural motifs that Alberti locked together on the facade of Sant' Andrea in Mantua were:

a. b.

How does the plan of the church break with a centuries-old Christian building tradition?

6. Explain the following terms with reference to Mantegna's *Camera degli Sposi* in Mantua (FIGS. 21-47 and 21-48):

trompe l'oeil

di sotto in su

What two concerns did Mantegna integrate in his painting of the *Dead Christ* (FIG. 21-48):

a.

b.

DISCUSSION QUESTIONS

1. What degree of Classical influence is found in Nanni di Banco's *Four Crowned Saints* (FIG. 21-4) in comparison with earlier works by Nicola Pisano (FIG. 19-2 and 19-3)) and the figures from Reims Cathedral (FIG. 18-24)? Note particularly the mastery of the contrapposto pose. In what way do Nanni di Banco's figures differ in relation to their architectural setting from the portal figures of French Gothic churches (FIG. 18-17 and 18-24)? How might this be related to the changing idea of human beings in the Renaissance as opposed to the Medieval world view.

2. How does Donatello's *Gattamelata* (FIG. 21-15) differ from the equestrian portrait of the emperor Marcus Aurelius (FIG. 10-59) and the Medieval *Bamberg Rider* (FIG. 18-50)? What was the apparent purpose of the high pedestal used with the *Gattemelata?*

3. Both the Church of the Katholikon (FIGS. 12-20 to 12-22) and the Pazzi Chapel (FIGS. 21-33 to 21-35) are characterized by a centralized plan, yet one is typical of Medieval Byzantine structures while the other is often used as the prime example of a Renaissance building. In what ways are the Humanism and rationality of the Renaissance apparent in Brunelleschi's building?

4. What characteristics of style are shared by Gentile da Fabriano's *Adoration of the Magi* (FIG. 21-17) and Uccello's *Battle of San Romano* (FIG. 21-26)? To what style do these characteristics relate? What feature of the Uccello work indicates that it was painted in the fifteenth century?

5. Explain the principles of linear perspective and discuss what made it so important for Renaissance artists. Select from Donatello's *Feast of Herod* (FIG. 21-8), Ghiberti's *Isaac and his Sons* (FIG. 21-3), Masaccio's *Holy Trinity* (FIG. 21-20), Uccello's *Battle of San Romano* (FIG. 21-26), Castagno's *Last Supper* (FIG. 21-22), Perigino's *Christ Delivering the Keys* (FIG. 21-40), Mantegna's *Foreshortened Christ* (FIG. 21-49), and Piero's *Brera's Altarpiece* (FIG. 21-42).

6. In what ways is Fra Angelico's *Annunciation* (FIG. 21-21) related to earlier versions like Simone Martini (FIG. 19-13)? What has he learned from artists like Masaccio?

7. Discuss the use of space and line and the placement of the figures in Fra Filippo Lippi's *Madonna and Child with Angels* (FIG. 21-23) and Giotto's version of the same theme (FIG. 19-8). What is the religious impact of the different figure types and of the landscape background used by Fra Filippo?

8. Compare Piero's *Flagellation of Christ* (FIG. 21-43) with *Duccio's Betrayal of Jesus* (FIG. 19-11). What changes has Piero made that lends his figures the air of monumental nobility?

9. Discuss the way in which Alberti utilized classical elements in the buildings he designed.

LOOKING CAREFULLY, DESCRIBING AND ANALYZING

Look carefully at the *October* page by the Limbourg brothers from the *Tres Riches Heures du duc de Berry* shown on page 544 and in FIG. 20-2) Write at least one page analyzing the image, using the following terms: form and composition; material and technique; space, mass and volume, line, and color. Describe each object that you see, starting from the bottom of the composition and going to the very top. How do the artists approach the composition? How do they divide the composition and how do they indicate that the space is three dimensional? How do the artists describe architectural and natural forms? How are human figures related to the environment both in scale and position.

Write at least one page analyzing Ghirlandaio's *Birth of the Virgin* (FIG. 31-32). Here are some questions that might help you with your analysis, but do not be limited by them. Start by carefully describing the setting. What sort of a room has the artist constructed? How is the space depicted? What classical decorative elements do you see? Then describe everything that you see within the space. How many figures are there? How do they relate to each other and how are they placed within the space? What role does each figure play in that subject? What is the subject? Is it sacred or secular? Is the setting consonant with a biblical scene? What does the setting and what do the costumes tell us about the time that the scene took place? What do you think the artist's reason was for portraying the scene as he did?

34

SUMMARY OF 15th CENTURY PAINTERS IN ITALY

Fill in as much of the chart as you can from memory. Check your answers against the text and complete the chart. Include additional material supplied by your instructor.

	Typical Examples	Stylistic Characteristics	Significant Historical Events, Ideas, etc.
Gentile da Fabriano City:			
Masaccio City:			
Fra Angelico City:			
Andrea del Castagno City:			
Ghirlandaio City:			
Uccello City:			

SUMMARY OF 15th CENTURY PAINTERS IN ITALY (continued)

	Typical Examples	Stylistic Characteristics	Significant Historical Events, Ideas, etc.
Botticelli City:			
Pollaiuolo City:			
Perugino City			
Piero della Francesca City:			
Mantegna City:			
Signorelli City:			

22
ITALY, 1500 TO 1600

TEXT PAGES 578-623

HIGH AND LATE RENAISSANCE

1. What dates are generally accepted as the span of the High Renaissance?

2. Name four artists who were most closely associated with the High Renaissance:

 a. b.

 c. d.

3. According to Leonardo, what was the major purpose of his scientific investigations?

 What two elements did Leonardo consider to be the heart of painting?

 a.

 b.

4. What compositional devices did Leonardo use in *The Virgin of the Rocks* (FIG. 22-2) to knit the figures together?

 a.

 b.

5. Define the following terms as they apply to art:

cartoon

chiaroscuro

desegno

sfumato

6. What two fifteenth-century trends does Leonardo synthesize in *The Last Supper* (FIG. 22-4)?

a.

b

7. Who was Julius II and why was he important for the history of art?

8. List three characteristics of Raphael's style as seen in the *Madonna of the Meadows* (FIG. 22-8).

a.

b.

c.

9. Name the four general themes Raphael used for his paintings in the Stanza della Segnatura.

 a. b.

 c. d.

10. Who are the two central figures represented in Raphael's *School of Athens* (FIG. 22-9), and what aspects of philosophy does each represent?

11. On the death of Julius II, a son of Lorenzo de' Medici was elected as Pope _____, and he became Raphael's patron.

12. The papal banker, Agostino Chigi, commissioned Raphael to decorate his villa with scenes from:

 How does the central figure of the *Galatea* scene (FIG 22-10) differ from Botticeli's *Venus* (FIG. 21-28)?

13. Who believed that the sculptor must fine the idea, the image locked in the stone, and then extract it from the block?

14. To what extent did Michelangelo utilize the mathematical procedures used by other Renaissance sculptors to achieve harmonious proportion?

15. What is meant by the term *terribilita?*

16. Briefly describe how Michelanagelo's *Pieta* (FIG. 22-12) differs from earlier versions of the theme such as the one shown on FIG. 18-51).

17. Name one figure that Michelangelo created for the tomb of Julius II:

Although some scholars do not believe that the so-called "slaves" or "captives" were created for the tomb of Julius II, figures like the Bound Slave (FIG. 22-16) are thought to represent:

18. Describe briefly the iconography of the tomb of Giuliano de' Medici (FIG. 22-17).

What, according to the Neo-Platonic interpretation, are the tombs thought to symbolize?

19. Briefly describe the iconography of the Sistine Chapel ceiling.

20. Characterize Michelangelo's style in painting and sculpture with four adjectives or phrases.

a.

b.

c.

d.

21. What was the effect of fthe color revealed during the restoration of the Sistine ceiling?

22. What scene did Pope Paul III commission Michelangelo to paint on the altar wall of the Sistine Chapel?

23. Briefly describe four aspects of the sculptural appearance of Bramante's *Tempietto* (FIG. 22-22).

a.

b.

c.

d.

The architect Palladio praised Bramante's *Tempietto* as the first which had brought back "the good and beautiful architecture" of antiquity. This comment, like Michelangelo's belief that the artist must reveal the higher truths nidden in nature comes from the Humanist revival of the teachings of the Greek philosopher _____.

24. Briefly describe Bramante's plan for the new St. Peter's:

How much of the building was completed during Bramante's lifetime?

25. Describe the changes Michelangelo made in Bramante's original designs for St. Peter's.

a. In the plan:

b. In the elevation:

26. Who designed the Palazzo Farnese (FIGS. 22-27 and 22-28)?

How does the Farnese Palace differ from the Palazzo Medici-Riccardi (FIG 21-36)?

27. What geometric forms did Palladio use to create the basic structure of the Villa Rotonda (FIG. 22-29 and 22-30)?

28. Describe the device Palladio used for the facade of San Giorgio Maggiore (FIG. 22-31) to integrate the high central nave and low aisles.

29. What was most signiificant about Palladio's writings?

30. What were the major formative influences on Bellini's style of painting?

31. What major characteristics found in Bellini's *San Zaccaria Altarpiece* (FIG. 22-33) distinguishes it from the similar subject portrayed by Piero della Francesca in his *Brera Altarpiece* (FIG. 21-42)?

32. What concerns distinguish the art of Venice from that of Florence and Rome?

Venice	Florence and Rome
a.	a.
b.	b.
c.	c.

33. What does the term "poesia" mean in reference to Venetian painting?

Name a work that exemplifies this approach:

34. Briefly describe three aspects of Giorgione's style.

 a.

 b.

 c.

35. The most outstanding feature of Titian's *Assumption of the Virgin* (FIG. 22-37) is:

36. What characteristics of Titian's *Madonna of the Pesaro Family* (FIG. 22-38) are typical of High Renaissance painting?

 a.

 b.

 What features of the work are not typical of the High Renaissance?

 a.

 b.

37. Which of Titian's paintings established the compositional essentials for the representation of the female nude in much of later Western art?

38. Who was Isabella d'Este. Explain the role she played as a patron of artists:

MANNERISM

1. Name three Mannerist painters.

 a. b. c.

 When did the Mannerist style emerge?

2. List five of the characteristics of Mannerist painting that can be called "anti-Classical" and that distinguish the Mannerist from the High Renaissance style.

 a.

 b.

 c.

 d.

 e.

3. List three characteristics that Sofonisba Anguissola's *Portrait of the Artist's Sisters and Brother* (FIG. 22-46) shares with other Mannerists portraits like those by Bronzino:

 a.

 b.

 c.

 List one feature that is uniquely hers:

 a.

4. Tintoretto aspired to combine the color of _____ with the drawing of _____.

5. What devices does Tintoretto use to identify Christ in his version of *The Last Supper* (FIG. 22-47)?

How did Leonardo identify him (FIG. 22-4)?

6. List two characteristics of Tintoretto's painting style that point toward the Baroque style:

a.

b.

7. Veronese's favorite subjects were

a. b.

To what aspects of his paintings did the Holy Office of the Inquisition object?

8. What is the difference in the type of illusion created by Veronese in *The Triumph of Venice* (FIG. 22-49) and that created by Correggio in *The Assumption of the Virgin* for the dome of Parma Cathedral (FIG. 22-50)?

9. Which Italian Mannerist sculptor worked for the French king Francis I?

10. Which Mannerist sculptor developed the compositional device of the spiral?

11. Describe at least four features of the Palazzo del Te that are "irregular" from the point of view of Renaissance architectural practice.

a.

b.

c.

d.

12. List three features of the Laurentian Library that can be considred Mannerist:

a.

b.

c.

13. The mother church of the Jesuit order, whose design would be highly influential, was built in Rome between _____ and _____It combined influences from a variety of sources.

Identify the sources of the following:

Scroll buttresses that unite upper and lower stories:

Classical pediment:

Paired pilasters:

Plan:

DISCUSSION QUESTIONS

1. How did the status of the visual artist change in the High Renaissance? What was the reason for this?

2. Compare the compositions of *The Last Supper* by Leonardo (FIG. 22-4), Andrea del Casatagno (FIG. 21-22) and Dirk Bouts (FIG. 20-12) from the point of view of style, handling of space and form, and dramatic impact.

3. Why is Bramante's Tempietto often referred to as the first High Renaissance building? What are the basic qualities that distinguish it from a typical Early Renaissance building? Do you feel that the building reflects a religious attitude that is different from the Medieval one? If so, what is the difference? How is it expressed?

4. How does the iconography of the Stanza della Segnatura relate to the ideals of the High Renaissance?

5. Compare Raphael's *Galatea* (FIG. 22-10) with Botticelli's *Birth of Venus* (FIG. 21-28); note the differences in the handling of space and the representation of the bodies. What are the sources for the two subjects?

6. Compare Michelangelo's *David* (FIG. 22-9) with Polykleitos' *Doryphoros* (FIG. 5-40) and Donatello's *David* (FIG. 21-12) from the stylistic point of view. What similarities do you see? what differences? What distinguishes Michelangelo's *David* as a High Renaissance figure?

7. Choose a typical composition by Raphael, one by Leonardo, and one by Michelangelo, and decide in what ways they are stylistically related and in what ways they differ. Do you think the differences relate to the personalities of the artists? Are the similarities helpful in allowing us to make any generalizations about High Renaissance style?

8. Compare Palladio's San Giorgio Maggiore (FIGS. 22-31 and 22-32) with Sant' Andrea in Mantua by Alberti (FIGS. 21-44 to 21-46). What differences do you see in the articulation of the facades and the interiors? Note also the degree of plasticity of the surfaces.

9. Compare Bronzino's *Venus, Cupid, Folly, and Time* (FIG. 22-44) with Giorgione's (and/or Titian's) *Pastoral Symphony* (FIG. 22-35). Note the poses of the figures, the settings, and the compositions. What do you think were the major concerns of each artist? How do these works reflect the different styles preferred by artists of Venice and those of Florence?

10. In what ways are the styles of the Early Renaissance in Florence, the High Renaissance in Rome, Mannerism in Florence, and the Late Renaissance in Venice typified in the portraits by Ghirlandaio (FIG. 21-25), Raphael (FIG. 22-11), Bronzino (FIG. 22-45), and Titian (FIG. 22-41)?

11. Compare Piero's *Brera Altarpiece* (FIG. 21-42), with Bellini's *San Zaccaria Altarpiece* (FIG. 22-33), and Parmigianino's *Madonna with the Long Neck* (FIG. 22-43); consider the handling of space, the logic (or lack of it) of the compositions, and the treatment of the figures, including placement and proportions. What emotional effect does each artist create? Which painting do you like best? Why?

12. Compare the facade designs of Antonio da Sangallo's Farnese Palace (FIG. 22-27), Alberti's Palazzo Rucellai (FIG. 21-38), and Giulio Romano's Palazzo del Te (FIGS. 22-53) and Palladio's Villa Rotonda (FIG. 22-29). Which building seems to be the most monumental? Why?

LOOKING CAREFULLY AND ANALYZING

Write at least a page comparing Leonardo's *Mona Lisa* (FIG. 22-5) with Ghirlandaio's *Portrait of Giovanna Tornobouni* (FIG. 21-25). Use the terms hue, line, mass, and chiaroscuro. Here are some questions that might help you with your analysis, but do not be limited by them. What changes had Leonardo made in the pose, the handling of light and the handling of detail? Consider the placement of the figures, the definition of form, and the emotional effect achieved by each artist in creating a portrait. Which do you like better ? Why?

SUMMARY OF 16th CENTURY PAINTERS IN ITALY

Fill in as much of the chart as you can from memory. Check your answers against the text and complete the chart. Include additional material supplied by your instructor.

	Typical Examples	Stylistic Characteristics	Significant Historical Events, Ideas, etc.
Leonardo da Vinci City:			
Raphael City:			
Michelangelo City:			
Bellini City:			
Giorgioni City:			
Titian City:			

SUMMARY OF 16th CENTURY ITALIAN PAINTERS (continued)

	Typical Examples	Stylistic Characteristics	Significant Historical Events, Ideas, etc.
Pontormo City:			
Parmigianino City:			
Bronzino City:			
Tintoretto City:			
Anguissola City:			
Correggio City:			
Veronese City:			

23
NORTHERN EUROPE AND SPAIN 1500-1600

TEXT PAGES 624-647

HOLY ROMAN EMPIRE

1. Who painted the *Isenheim Altarpiece* (FIG. 23-2)?

List three characteristics of the artist's style.
a.

b.

c.

What subject is depicted on the center panel?

On the exterior wings?

On the interior wings?

What was its purpose?

For what type of institution was the altarpiece created?

What was the reason for including Saints Sebastian and Anthony on the wings?

2. Name an artist who was interested in witches?

3. Name the sixteenth century Northern artist who became an international art celebrity:

What did he do to try to stop other artists from copying his work?

4. What interests botanists about Durer's representaton of the *Great Piece Of Turf* (FIG. 23-4)?

5. List two elements of Durer's *Adam and Eve* (FIG. 23-1) that reflect his study of Italian models:

 a.

 b.

 The poses of Adam and Eve are similar to the figures of _____ and _____.

 List one element that demonstrates his Northern commitment to Naturalism:

6. Name two tendencies that Durer fuses in *Knight Death and the Devil* (FIG. 23-5):

 a.

 b.

7. How does Durer's support for Lutheran doctrine reflected in *The Four Apostles* (FIG. 23-6)?

8. Who was Martin Luther and what was his goal when he posted his ninety-five theses in Wittenburg?

9. What medium was used for Cranach's *Allegory of Law and Grace* (FIG. 23-7)?

 Why was the medium approved by Protestants when large altarpieces were not?

 What image did Cranach use to describe Catholic Doctrine?

 To describe Protestant doctrine?

10. As he began a campaign against the Turks, the Duke of Bavaria commissioned the artist _____ to paint the historic confliece between Alexander the Great and _____. In what day did the artist emphasize the connection between the ancient battle and contemporary times?

What stylistic effects did he utilize to emphasize the violence of the battle?

11. List three Italiante elements that Holbein integrated into his painting:

a.

b.

c.

List the elements that reflect his Northern training:

a.

b.

12. What does *anamorphic* mean?

FRANCE

1. Who painted a famous portrait of Francis I shown in (FIG. 22-10) ?

2. Name two Italian Mannerists who were instrumental in bringing the Mannerist style to France:

a. b.

3. List three Italian Renaissance features of the Chateau of Chambord:
 a.

 b.

 c.

 List two French Gothic features:
 a.

 b.

4. The architect who designed the Cour Carré (Square Court) of the Louvre (FIG. 23-12) was:

 Identify those features of the facade that are derived from the Italian Renaissance:

 a.

 b.

 c.

 Identify those features of the facade that are essentially French.

 a.

 b.

 c.

5. List three characteristics of the French classical architecture that were copied in other Northern European countries:

 a.

 b.

 c.

THE NETHERLANDS

1. What are the primary subjects of the panels of Bosch's *Garden of Earthly Delights* (FIG. 23-13)?

 Left:

 Center:

 Right:

2. What features of Jan Gossaert *Neptune and Amphitrite* (FIG. 23-14) are classical?

 Which are not?

3. In what ways does Quinten Massy's *Money-Changer and His Wife* (FIG. 23-15) reflect both the economic and religious life of Antwerp in the early sixteenth century? List features that relate to each.

 Economic Life:

 Religious life:

4. List three religious features found in Aertsen's *Meat Still Life* (FIG. 23-16):

5. The *Self-Portrait* in FIG 23-17 by _____ is purportedly the first known self-portrait by a European woman.

6. Lavina Teerlinc worked as a royal portraitist in _____.

7. Joachim Patiner was best known for his paintings of _____.

8. List three characteristics of Bruegel's landscape paintings:

a.

b.

c.

SPAIN

1. Identify plateresque.

2. List three stylistic characteristics of the Collegio de San Gregorio in Valladlid (FIG. 23-22):

a.

b.

c.

3. List two plateresque features of the Portal of the Casa de Montejo in Merida Mexico (FIG. 23-23):

a.

b.

c.

4. The Escorial was constructed for King_____ of Spain.

Describe the style of the building.

5. Describe two elements of El Greco's style that seem to be related to Italian Mannerism.

a.

b.

Describe two elements that point toward the Baroque.
a.

b.

Describe two purely personal stylistic traits that are found in El Greco's work.

a.

b.

DISCUSSION QUESTIONS

1. What different conceptions of the nude and of Classical mythology are apparent in Raphael's *Galatea* (FIG. 22-10) and Gossaert's *Neptune and Amphitrite* (FIG. 23-14)?

2. Compare Grunewald's *Isenheim Altarpiece* (FIGS. 23-2) with Jan van Eyck's *Ghent Altarpiece* (FIGS. 20-5 and 20-6). Discuss the iconography, the handling of light, color, and space, as well as the emotional impact. What kind of landscape setting does each use? How does each treat the human figure?

3. Compare the pose and proportions of *Adam and Eve* in the representations by Van Eyck (FIG. 20-6), Massaccio (FIG. 21-19), and Durer (FIG. 23-1). How do these figures relate to classical proportions and the contrapposto pose?

5. In what ways do you think Durer and Leonardo were alike? In what ways do you think they were different?

6. Discuss the combination of Northern and Italinate tendencies in Durer's work, selecting from the *Four Apostles* (FIG. 23-6), *Fall of Man* (FIG. 23-1), *The Great Piece of Turf* (FIG. 23-4), and *Knight Death and the Devil* (FIG. 23-5). How might Durer's statement relate to these tendencies: "We regard a form and figure out of nature with more pleasure than any other, though the thing itself is not necessarily altogether better or worse."

7. Compare the classicism of the Escorial (FIG. 23-24) with that of the Chateau de Chambord (FIG. 23-11). What does each building tell about the life and interests of the kings who commissioned them?

8. What stylistic features does the work by El Greco (FIG. 23-25) share with the following artists: Parmigianino (FIG. 22-43), Tintoretto (FIG. 22-47), and Pontormo (FIG. 23-42)? How does his work differ from theirs?

9. Find an important Italian work that was done about the same time as *The Isenheim Altarpiece* (FIGS. 23-2) and analyze the differences between the works.

10. Scholars give very different interpretations of Bosch's *Garden of Earthly Delights* (FIG. 23-13). Which do you think might be a good explanation of the work? Why?

LOOKING CAREFULLY, DESCRIBING AND ANALYZING

Look carefully at Holbein's *French Ambassadors* on Fig 23-9 and write at least a page describing and analyzing it. Here are some questions that might help you with your analysis, but do not be limited by them. First look at the space that is defined in the composiition. Examine the floor, the curtain and the table. What is on the table? See how many objects you can find and then carefully describe each of them, considering the texture, the pattern and the color of each, and whether or not foreshortening was used. What do you think each object was used for? Describe the strange object in the lower center of the picture. What is it, and how did Holbein depict it? What relation might it have to the two men?

Next describe the two figures : the clothes they wear; the way they stand. How does Holbein indicate their position in space? Does one seem more dominant than the other? What do the objects on the table tell us about each of them? Which do you think belonged to each man? What do you think each of the men did for a living, based on what Holbein shows us? What do the expressions on their faces tell us about their personalities. Which one do you think you would like the most? Why?

SUMMARY OF 16th CENTURY ARTISTS IN NORTHERN EUROPE & SPAIN

Fill in as much of the chart as you can from memory. Check your answers against the text and complete the chart. Include additional material supplied by your instructor.

	Typical Examples	Stylistic Characteristics	Significant Historical Events, Ideas, etc.
Grunewald Nationality:			
Baldung Grien Nationality:			
Durer Nationality:			
Cranach Nationality:			
Altdorfer Nationality:			
Holbein Nationality:			
Clouet Nationality:			
Lescot Nationality:			
Bosch Nationality:			

SUMMARY OF 16th CENTURY ARTISTS IN NORTHERN EUROPE & SPAIN
(continued)

	Typical Examples	Stylistic Characteristics	Significant Historical Events, Ideas, etc.
Gossart Nationality:			
Massys Nationality:			
Aertsen Nationality:			
Van Hemessen Nationality:			
Terling Nationality:			
Patiner Nationality:			
Bruegel Nationality:			
Herrera Nationality:			
El Greco Nationality:			

24
ITALY AND SPAIN, 1600 TO 1700

TEXT PAGES 648-671

List three adjectives or phrases that were embraced by many Baroque artists:

a.

b.

c.

ITALY

1. With what religious movement is much of the Baroque art in Catholic countries associated?

2. What city was the focus of artistic patronage as the Catholic church tried to reestablish its primacy?

3. List three ways in which Maderno's Early Baroque church of Santa Susanna (FIG. 24-2) resembles the church of Il Gesu (FIG. 22-55):

a.

b.

c.

List three ways in which it differs:

a.

b.

c.

4. Name four architects who worked on St. Peter's and note the primary contribution of each.

a.

b.

c.

d.

5. Identify the following terms:

Atrium

Baldacchino

Piazza

6. List four major characteristics of Bernini's sculpture that are typical of Baroque art in general.

a.

b.

c.

d.

7. In what way did Bernini depict the vision of St. Theresa (FIG 24-1 and 24-8)?

8. Who developed the "sculptural" architectural style to its extreme?

Name two buildings designed by him.

b. c.

 Both are located in the city of _____.

9. While the circle had been the ideal geometric figure to Renaissance architects, Baroque planners preferred the :

 Why?

10. List three assumptions that were basic to the teaching of art at the Bolognese academy.

a.

b.

c.

11. Who is credited with developing the "classical" or "ideal" landscape?

 What were its roots?

12. What earlier work strongly influenced Annibale Carracci's ceiling frescoes in the gallery of the Farnese Palace in Rome (FIG. 24-16)?

 How did Carracci modify the original to achieve heightened illusionism?

13. What is *quadro riportato* and how was it used?

14. The common purpose of Caravaggio's *Conversion of St. Paul* (FIG. 24-17) and Bernini's *The Ecstasy of St. Theresa* (FIG. 24-8) was:

15. List three characteristics of Caravaggio's style.

a.

b.

c.

16. What was Caravaggio attempting to present in his religious pictures?

What pictorial devices did he use to achieve his goal?

17. What is **tenebroso**?

List two countries where it was particularly inflential:

a. b.

18. Which artists most influenced the style of Artemesia Gentileschi?

Who were Judith and Holophernes?

What techniques does Artemesia use to portray the drama of the theme?

19. Name two influences blended by Reni in his *Aurora* fresco (FIG. 24-21):

a.

b.

20. List three ways in which Pietro da Cortona's frescoed ceiling in the Palazzo Barberini (FIG. 24-22) praised his patron:

a.

b.

c.

21. What effect did Gaulli create with the fresco he painted on the ceiling of Il Gesu in Rome:

List three devices he used to achieve that effect:

a.

b.

c.

22. The painter beside Gaulli who worked for the Jesuits in Rome was

_____.

He painted the ceiling of the church of _____ for them.

What device did he use to merge heaven and earth?

SPAIN

1. Name two Spanish rulers from the Hapsburg dynasty who were patrons of the arts:

 a. b.

2. What was the goal of many Spanish religious artists?

 Name a theme that was particularly popular among them:

3. Ribera's style was influenced by the "dark manner" of:

4. What type of lighting did Zurbaran use in his painting of *Saint Serapion* (FIG. 24-26)?

5. Velazquez was court painter to King _____.

6. What does Velasquez's *Surrender of Breda (FIG. 24-29)* commemorate?

7. What is the subject of *Las Meninas (FIG. 24-30)?*

 How many levels of reality can you find in the picture?

 Briefly describe them.

 What painting technique did Velazquez use in *Las Meninas?*

DISCUSSION QUESTIONS

1. Study the elevations and plans of Bramanti's Pazzi Chapel (FIGS. 21-33 to 21-35-19) and Borromini's San Carlo alle Quattro Fontane (FIGS. 24-9 to 24-11). Contrast the basic shapes used in the plans, and describe how these forms relate to the elevations of the buildings.

2. Bernini's art has been described as "theatrical." give examples of its theatricality and discuss the technical devices he used to create them.

Compare Bernini's *David* (FIG. 24-8) with Michelangelo's version (FIG. 22-9). Discuss the pose of the figures, the closed or open quality of the composition, and the mood that is created by

3. Compare Ribera's *Martyrdom of St. Bartholomew* (FIG. 24-25) with Piero dellaa Francesca's *Flagellation of Christ* (FIG. 21-1 and FIG. 21-43). Discuss composition, painting technique, and emotional impact. What major concerns of the Italian Renaissance and the Counter-Reformation in Spain are demonstrated by these works?

4. Compare the ceiling painting of Correggio in Parma (FIG, 22-50) with those of Mantegna (FIG, 21-48), Veronese (FIG, 22-47), Annibale Caracci (FIG, 24-16), Reni (FIG, 24-21), Pietro da Cortona (FIG, 22-25), and Pozzo (FIG, 24-24). Which is closest to his work, and what features do they share?

5. Discuss the career of Artemisia Gentileschi noting particularly the ways in which it was affected because she was a woman.

LOOKING CAREFULLY, DESCRIBING AND ANALYZING

In *Las Meninas* Velasquez demonstrated his mastery of the depiction of complex levels of visual reality (FIG. 24-30). Study the painting very carefully and write an essay of at least one page describing it. Here are some questions that might help you with your analysis, but do not be limited by them. First describe the room in which he has placed the majority of the figures and describe each of the figures in that space. Then look for other figures an describe the space in which they would be standing. Describe the artist's brushwork and his use of light and dark and note he uses these elements to increase the sense of reality of the scene.

SUMMARY OF 17th CENTURY PAINTERS IN ITALY & SPAIN

Fill in as much of the chart as you can from memory. Check your answers against the text and complete the chart. Include additional material supplied by your instructor.

	Typical Examples	Stylistic Characteristics	Significant Historical Events, Ideas, etc.
Annibale Caracci Nationality:			
Caravaggio Nationality:			
Gentileschi Nationality:			
Reni Nationality:			
Petro da Cortona Nationality:			
Gaulli Nationality:			
Pozzo Nationality:			
Rivera Nationality:			
Zurbaran Nationality:			
Velasquez Nationality:			

25
NORTHERN EUROPE, 1600 TO 1700

TEXT PAGES 672-703

1. List two important results of the Treaty of Westfalia:

a.

b.

2. Name three new food products that came to Europe as a result of expanded trade in the 17th century:

 a. b. c.

 Name three products that were based on slave labor:

 a. b. c.

FLANDERS

1. Which religious belief was most important for 17th century Flemish painters?

Which religious belief was most important for 17th century Dutch painters?

2. Rubens synthesized his study of classical antiquity with the work

of the Italian masters

_____,_____and_____

while adding his own dynamism.

3. Rubens combined his painting with his diplomatic skills. Name three of the rulers he worked for:

 a. b. c.

4. List three features that contribute to the drama of Rubens' *Elevation of the Cross* (FIG. 25-2):

a.

b.

c.

5. What member of the famous Florentine House of Medici commissioned Rubens to paint a cycle memorializing and glorifying her career and that of her late husband?

6. Name the painting that embodies Rubens' attitude toward war:

What did the following allegorical figures symbolize?

Monsters:

Woman with a broken lute:

Architect fallen backwards:

Book and paper at the feet of Mars:

Sorrowing woman in black:

7. In what type of paintings did Van Dyck specialize?

How could his style best be characterized?

8. In what type of subject matter did Clara Peeters specialize?

DUTCH REPUBLIC

1. How did the religious and economic conditions in seventeenth-century Holland effect artistic patronage and production?

a.

b.

c.

2. Inwhat way was the work of Gerrit van Honthorst influenced by Caravaggio?

3. Frans Hals was the leading painter of the_____school, and specialized in_____.

What are the main elements of his style that distinguish his works from those of his contemporaries?

Write down two adjectives that describe his style:

a. b.

4. For what genre was the Dutch painter Judith Leyster most famous?

 What characteristic did she share with Hals?

5. Who commissioned Rembrandt to paint *The Anatomy of Dr. Tulp* (FIG. 25-12)?

 What does this tell us about paronage in Holland during the 17th century?

6. What feature of *The Company of Captain Frans Fanning Coq* (FIG. 25-13) led to its being misnamed *The Night Watch*?

What devices did Rembrant use to enliven the group portrait?

7. List three adjectives or phrases that would contrast Rembrandt's religious works to Counter-Reformation art works:

a.

b.

c.

8. What was Rembrandt trying to express in his portraits and self-portraits?

9. Briefly describe Rembrandt's use of light and shade.

10. How does his use of light and shade effect the mood of his later portraits?

11. Briefly describe the technique of etching.

What are its advantages over engraving?

12. What reason could be given for the Dutch interest in landscape painting?

Name two artists who specialized in it:

a. b.

13. What was Vermeer's favorite type of subject matter?

In what way does Vermeer's use of light differ from Rembrandt's?

14. On what principle does a *camera obscura* work?

15. List three important facts about the optics of color that are illustrated in Vermeer's paintings:

a.

b.

c.

16. How does the mood created by Steen's interiors differ from that created by Vermeer's?

17. What might the children's behavior symbolize in Steen's *Feast of St. Nicholas* (FIG. 24-20)?

18. What is a "Vanitas" still life?

19. The paintings of Rachael Ruysch reflect a particular interest in:

FRANCE

1. Which French artist is credited with having established seventeenth-century Classical painting?

Where did he spend most of his life?

What two Italian artists did he most admire?

2. What four characteristics of *Et in Arcadia Ego* (FIG. 25-24) are typical of Poussin's fully developed Classical style?

a.

b.

c.

d.

3. What type of subjects did Poussin consider to be appropriate for paintings done in the "grand manner"?

What did he think should be avoided?

4. Poussin and Rubens were considered as the two poles in the Baroque debate between the forces of passion and reason. Which pole do you think each artist represented? What characteristics in the work of each artist do you thinnk would reflect those attitudes?

Rubens:

Poussin:

5. In what major way does the landscape in Poussin's *Burial of Phocion* (FIG. 25-25) differ from Van Ruisdael's *View of Haarlem* (FIG. 25-18)?

6. What was Claude Lorrain's primary interest in landscape painting?

 In what country did he do most of his painting?

7. The life of French peasants was the favorite subject of _____.

How do his depictions differ from those of the Dutch painter Jan Steen?

8. The French artist Callot is best known for his works done in the medium of
_____. His *Miseries* series realistically depicts scenes
of _____.

9. Which French artist was most influenced by the northern "Caravaggisti"?

In what ways does his style differ from theirs?

10. What was the political meaning of Louis XIV's appelation "le Roi Soleil"?

 What was his significance as a patron of the arts?

11. The French Royal Academy of Painting and Sculpture was established in the year
_____.

 What was its primary purpose?

12. List three features of Rigaud's portrait of Louis XIV (FIG. 25-30) that contributed to Louis' personification of an absolute monarch:

a.

b.

c.

13. What three architects collaborated to design the east facade of the Louvre?

a. b. c.

What form was used for the central pavilion of the facade?

14. Who was the principal director for the building and decoration of the Palace of Versailles?

Who designed the park of Versailles?

What was symbolized by the vast complex of Versailles?

15. List two sources for Girardon's portrayal of *Apollo Attended by the Nymphs* carved for the Park of Versailles:

a. b.

16. Which feature of Jules Hardouin-Mansart's Eglise du Dome (Church of the Invalides) is most Baroque?

Which is most classical?

ENGLAND

1. Which of the visual or plastic arts was most important in seventeenth-century England?

2. Name the Italian architect who had the strongest influence on the buildings of Inigo Jones?

3. Who designed St. Paul's Cathedral in London (FIG. 25-38)?

What feature of the building shows the influence of Borromini?

What feature is taken over from the east facade of the Louvre?

DISCUSSION QUESTIONS

1. Discuss the influence of Caravaggio on Gerrit van Honthorst (FIG. 25-8), George de la Tour (FIG. 25-29), and Louis le Nain (FIG. 25-27). Which aspects of Caravaggio's style did each adopt, and how do their works differ from him and from each other?

2. In what ways do the works and lives of Rubens and Rembrandt reflect the different social and religious orientations of seventeenth-century Flanders and Holland?

3. Compare Rembrandt's *Self-Portrait* (FIG. 25-15) with the self-portraits by Judith Leyster (FIG. 25-11) and Caterina van Hemessen (FIG. 23-17), and Van Eyck's *Man in a Red Turban* (FIG 20-7) How have the artists depicted the different psychological states as they look at themselves? Do you think these works illustrate major differences in the philosophies of the times and/or places where painted or that the interpretations were solely individual? Why?

4. What was the effect of the economic and religious climate of seventeenth-century Holland on its artists?

5. Discuss the relative balance between Baroque and Renaissance features in the following buildings: the east facade of the Louvre (FIG. 25-31), the Church of the Invalides in Paris (FIG. 25-36), the Banqueting House at Whitehall (FIG. 25-37), and St. Paul's Cathedral in London (FIG. 25-38).

6. In what ways did Louis XIV influence French art of the seventeenth century? How did his utilization of art differ from that of Philip IV in Spain?

7. Could Velasquez's *Surrender at Breda* (FIG. 24-29) and Steen's *Feast of St. Nicholas* (FIG. 25-20) serve as illustrations of Poussin's "grand manner"? If not, why not?

Who was chiefly responsible for the development of "classical" landscape painting in Italy? How did his approach differ from those of Poussin (FIG. 25-25), Claude (FIG. 25-26), and Van Ruisdael (FIG. 25-18)?

LOOKING CAREFULLY, DESCRIBING AND ANALYZING

In *The Letter* Vermeer used both mirrors and the camera obscura to depict complex levels of visual reality (FIG. 25-19). Study the painting very carefully and write an essay of at least one page describing it. Here are some questions that might help you with your analysis, but do not be limited by them. First describe the room in which he has placed the figures and describe each of the figures in that space. Then look at the still life objects in the foreground and describe each carefully. How do you think he used he camera obscura and the mirror in his depiction. Describe the artist's brushwork and his use of light and dark and note he uses these elements to increase the sense of reality of the scene.

SUMMARY OF 17th CENTURY PAINTERS IN NORTHERN EUROPE

Fill in as much of the chart as you can from memory. Check your answers against the text and complete the chart. Include additional material supplied by your instructor.

	Typical Examples	Stylistic Characteristics	Significant Historical Events, Ideas, etc.
Rubens Country:			
Van Dyck Country:			
Peters Country:			
Ter Brugghen Country:			
Honthorst Country:			
Hals Country:			
Leyster Country:			
Rembrandt Country:			
Cuyp Country:			

SUMMARY OF 17th CENTURY PAINTERS IN NORTHERN EUROPE
(continued)

	Typical Examples	Stylistic Characteristics	Significant Historical Events, Ideas, etc.
Ruisdael Country:			
Vermeer Country:			
Steen Country:			
Kalf Country:			
Poussin Country:			
Lorrain Country:			
Callot Country:			
De la Tour Country:			
Rigaud Country:			

SUMMARY OF 17th CENTURY SCULPTURE & ARCHITECTURE

Fill in as much of the chart as you can from memory. Check your answers against the text and complete the chart. Include additional material supplied by your instructor.

	Typical Examples	Stylistic Characteristics	Significant Historical Events, Ideas, etc.
Maderno Country:			
Bernini Country:			
Borromini Country:			
Perrault Country:			
Girardon Country:			
Hardouin-Mansart & LeBrun Country:			
Jones Country:			
Wren Country:			

26
SOUTH AND SOUTHEAST ASIA AFTER 1200

TEXT PAGES 704-717

1. Name the new religion that gained adherents in India from the thirteenth through the fifteenth century:

2. What was the purpose of the minaret called the Qutb Minar that was erected in Delhi in the 15th century?

3. Review the following architectural terms and write down what they mean: Draw a sketch if appropriate.

 mosque

 minaret

 vimana

 mandapa

 gopura

4. Name one powerful Hindu kingdom that ruled from the 14th through the 16th centuries in Southern India:

5. Identify the following:

Mughals

Akbar

Jahangir

6. What is the meaning of Akbar controlling the elephant that is seen in FIG. 26-4?

7. List three ways in which the artist Bichitr symbolized the power of Jahangir in the miniature illustrated in FIG. 26-5.

a.

b.

c.

8. What was the purpose of the Taj Mahal?

What is thought to have been its symbolic meaning?

How does it differ from earlier Islamic tombs like the one for Sultan Hasan in Cairo (FIGS. 13-18 and 13-19)

What aesthetic effect does it create?

9. Who were the Rajputs?

10. List four stylistic elements of the miniature of *Krishna and Radha in a Pavillion* (FIG. 26-7).

 a.

 b.

 c.

 d.

 Who was Krishna ?

 What is the meaning of the lightning?

 What did the love between Krishna and Radha symbolize?

11. List two features that characterize south Indian temple complexes like the one at Madurai (FIG. 26-8):

 a.

 b.

12. What was the purpose of the East India Company?

13. What is the significance of the Victoria Terminus?

SOUTH EAST ASIA

1. List two Southeast Asian countries that practice Theravada Buddhism:

 a. b.

2. List three stylistic features of Buddha figures from Sukhotai like the one shown on FIG. 26-11.

 a.

 b.

 c.

3. What material did Thai artists prefer to use for sculpture?

4. What power attributed to the *Emerald Buddha* (FIG. 26-12) symbolized the combined religious and secular powers of the King?

5. What relic is contained in the Shwedagon Pagoda in Rangoon (FIG. 26-12)?

 How tall is the pagoda?

 How is it decorated?

6. Vietnam has a particularly strong tradition in the art of :

7. What technique is illustrated in the work shown in FIG. 26-14)?

 What aspect of the work shows Chinese influence?

 What aspect is typically Vietnamese?

DISCUSSION QUESTIONS

1. Compare the Buddhist structures at the following sites: Sanchi (FIGS. 6-7), Borobudur (FIG. 6-27), Rangoon (Yangon) (FIG. 26-13), Byodoin, Uji (FIG. 8-13), Ankor Wat (FIG. 6-30), and Yingxian (FIG. 7-23). What was the purpose of each, and how is that purpose reflected in the forms?

2. Compare the Buddhas from Gandhara (FIG. 6-10), Mathura (FIG. 6-12), Sarnath (FIG. 6-13), Polonnaruwa (FIG. 6-26), Sukhothai (FIG. 26-11), Bangkok (FIG. 26-12), Sokkuram (FIG. 7-28), Nara (FIGS. 8-1), Longmen (FIG. 7-14), and the Zhoa Dynasty (FIG. 7-11), Do you see any stylistic development over time and do you see any national characteristics? If so, describe them.

3. Compare the Hindu temple the Lotus Mahal (FIG. 26-3), with the following: Thamjavur (FIG. 6-22), Khajuraho (FIG. 6-23), Mamallapuram (FIG. 6-21), and Angkor Wat (FIG. 6-29), Which does it most resemble? In what way?

4. Compare the Hindu temple at Madurai (FIG. 26-8) with the Buddhist Schwedagon Pagoda at Rangoon (Yangon) (FIG. 26-13). How and why are they different?

5. Compare the 18th century miniature of *Krishna and Radha* (FIG. 26-7) with Fragonard's *The Swing* shown in FIG. 28-1. While both depict lovers, the philosophies behind them are very different. Discuss these differences.

6. Compare the Mughal battle scene shown on FIG. 26-4 with the Italian battle shown on FIG. 21-26. In what ways are they similar and in what ways are they different? How does each handle space and color?

7. Compare the Islamic mausoleums shown on FIG. 26-1 and FIG. 13-18Who was each built for, and how did that affect the style and the setting? Which do you think is the most beautiful? Why?

LOOKING CAREFULLY, DESCRIBING AND ANALYZING

Write at least two pages analyzing Bichitr's picture of *Jahinger Preferring a Sufi Shaykh to Kings* (FIG. 25-5). Look carefully at each element of the painting and describe everything that you see. After describing the objects , analyze their style. Use the following terms in your analysis: foreshortening, picture plane, hue, line, pattern, shape and mass. What elements come from the Islamic tradition and which show influences from Western art? Then look thorough the text and see if you can find objects or images that relate to what you have written.

SUMMARY OF SOUTH AND SOUTH EAST ASIA AFTER 1200

Using the information on page 717 of the text, enter the approximate dates for the following periods.

Sultanate of Delhi:_____ to _____
Vijayanagaar Empire: _____ to _____
Mughal Empire: _____ to _____
Nayak Dynasty S. India: _____ to _____
British Colonial Period: _____ to _____

Fill in as much of the chart as you can from memory. Check your answers against the text and complete the chart. Include additional material supplied by your instructor.

	Typical Examples	Stylistic Characteristics	Significant Historical Events, Ideas, etc.
Sultanate of Delhi			
Nayak Dynasty			
Hindu Rajput Kingdoms			
British Colonial India			
Thailand			
Myanmar (Cambodia)			
Vietnam			

27
CHINA AND KOREA AFTER 1279

TEXT PAGES 718-733

CHINA

1. Before conquering China in _____ members of the Yuan Dynasty
 were nomads known as _____. They dominated China until
 _____.

2. Who was Kublai Kahn and what effect did he have on art production?

3. Why was the depiction of bamboo so popular with Chinese painters?

4. Who were the "literati"?

 Briefly characterize their style:

5. Why was true porcelain so much admired?

 What was it made of?

 How was it fired?

 What is the difference between underglaze and overglaze?

And what colors can be used in each?

underglaze:

overglaze:

6. Was the vase shown in FIG. 27-5 done using underglaze or overglaze techniques?

7. What do the following symbolize in Chinese art?

Bamboo

Dragon

Phoenix

8. Where is the Hall of Supreme Harmony located?

What was its purpose?

9. What is a traditional Chinese garden supposed to replicate?

What is its purpose?

10. What are fantastic rocks supposed to represent?

11. How is lacquer ware created?

12. Describe the role that calligraphy played in Chinese painting:

13. How did the work of Ming court painters differ from that of the literati both in purpose and in style?

14. What aspect of the work of Dong Qichang led critics to call him the "first modernist painter"?

15. Name the artist who specialized in the painting of flowers during the Ming period:

 Describe her style:

16. The creative use of the "single brushstroke" or "primordial line" was advocated by the Qing painter _____.

17. Who was Guiseppe Castiglione?

 What feature of his work is distinctly European?

 What features has he adopted from the Chinese literati painter?

18. What style did Marxism inspire in China?

19. In *A Book from Heaven* (FIG. 27-18) the twentieth century artist Xu Bing attempted to blend _____ with _____.

KOREA

1. The Chosen Dynasty ruled in _____ from 1392-1910.

2. What was the Nandeamun (gateway) into Seoul intended to symbolize?

3. What is meant by "true view" painting?

4. Name a Western influence in the work of Song Su-Nam:

 Name an Eastern influence?

DISCUSSION QUESTIONS

1. Discuss the effects of political and religious changes on Chinese artists of the sixteenth century. Cite specific works to illustrate your discussion.

2. What is the major difference between Chinese or Korean and Western attitudes toward nature? How have these attitudes been reflected in art? Select three examples of each to illustrate your discussion.

3. Compare the style of the Yuan painters shown on FIGS. 27-3 to 27-5 with that earlier painters like Fan Kuan (FIG. 7-20) and Ma Yuan (FIG. 7-24). What similarities and what differences do you see?

4. Compare the structure of the Forbidden City shown on FIG. 27-1 and 27-6 with Louis XIV's Palace of Versailles (FIG. 25-32 and 25-33). What features do they share? In what way do the structures reflect the political philosophies of their creators?

5. Compare the portrait of Guan Yo (FIG. 27-10) with the following portraits of rulers: the Tang emperor on FIG. 7-17, King Suryavarman II from Angkor Thom (FIG. 6-31), Jahangir (FIG. 26-5), Jaswant Singh (FIG. 26-10), Khafre (FIG. 3-12), Augustus Caesar (FIG. 10-27), the Mayan ruler 13 (FIG. 14-9), the King of Ife (FIG. 15-6), Francis I (FIG. 23-10) and Louis XIV of France (FIG. 25-30). How does each portrait use accessories to emphasize the power of the subject? Which looks most majestic? Which portrait do you like best? Why?

LOOKING CAREFULLY, DESCRIBING AND ANALYZING

Look carefully at the painting of *Stalks of Bamboo by a Rock* shown on FIG. 27-3, and write at least one page analyzing it. Use the following terms: form and composition; material and technique; line and color; space, mass and volume, picture plane. The material and technique are very important in this work.

Here are some thoughts that might help you with your analysis, but do not be limited by them. Describe the objects that are shown in the painting, noting the different types of brush strokes and amount of ink used to create each form. What sort of shapes and volumes are created? Is there any sense of space in the composition, and if there is, how did the artist create it. Describe the calligraphy and the stamps that you see. What do you think was the purpose of these additions to the basic scene?

SUMMARY OF CHINA AND KOREA AFTER 1279

Using the information on page 733 of the text, enter the approximate dates for the following periods.

Yuan Dynasty:_____ to _____

Ming Dynasty: _____ to _____

Qing Dynasty: _____ to _____

Modern China: _____ to _____

Korea: _____ to _____

Fill in as much of the chart as you can from memory. Check your answers against the text and complete the chart. Include additional material supplied by your instructor.

	Typical Examples	Stylistic Characteristics	Significant Historical Events, Ideas, etc.
Yuan Dynasty			
Ming Dynasty			
Qing Dynasty			
Modern China			
Korea			

28
JAPAN AFTER 1336

TEXT PAGES 734-748

JAPAN 1336 TO 1868

1. What about Zen appealed to the samuri?

2. What was the purpose of the dry garden at Saihoji (FIG. 28-2)

3. Name the fifteenth century master who created "broken" or "splashed-ink" paintings:

 Describe his technique:

4. List two features that characterize the style of Mononobu and the Kano school:

 a.

 b.

5. What art form was most popular for the painted decorations of the Momoyama period?

6. Briefly contrast the styles of the following Momoyama painters:

 Kano Eitoku

 Hasegawa Tohaku

7. Name the religious sect that influenced the development of the Japanese tea ceremony.

What was the purpose of the tea ceremony?

Briefly characterize the style of vessels and buildings used in it:

8. What was the source of many of the features used the Katsura Imperial Villa (FIG. 28-9)?

List three factors that were important in creating the aesthetic effect of the building:

a.

b.

c.

What feature helped blend the interior with the exterior of the building?

9. List two ways in which the work of artists of the Rinpa School differed from those of the Kano and Tosa schools:

a.

b.

10. How were Japanese literati painters different from the Chinese literati whose work they emulated?

11. Who were the purchasers of Japanese wood block prints?

12. Name an eighteenth century Japanese artist who used wood lock prints to illustrate subjects from everyday life:

13. Name a Japanese printmaker who specialized in landscapes:

MODERN JAPAN

1. Name three western techniques incorporated by Japanese Nihonga painters:

 a.

 b.

 c.

2. What structural system did Kenzo Tange utilize for his design of the Olympic stadium shown in FIG. 28-16?

3. What is a Japanese "living national treasure"?

 Name one:

REVIEW

List the major art form used by each of the following artists and the century in which they worked:

	Art Form	Century
Hamada Shogi		
Hasegawa Tohaku		
Hokusai		
Honami Koetsu		

	Art Form	Century
Kano Montonobu		
Kano Eitoku		
Toyo Sesshu		
Suzuki Harunobu		
Takahashi Yuichi		
Tsuchiya Kimio		
Yosa Buson		

DISCUSSION QUESTIONS

1. In what way does the Japanese tea ceremony relate to the style of the painting illustrated in (FIG. 28-3)?

2. Compare a Harunobu print (FIG. 28-12) with Degas' *The Tub* (FIG. 31-11). In what ways does Degas's composition resemble that of the Japanese print? What relation so you see between Hokusai's *Great Wave* (FIG. 28-13) and Van Gogh's *Starry Night* (FIG. 31-17)? Discuss the treatment of the surface and the conception of space.

3. What can you tell abou the Japanese attitude toward nature from Hasegawa Tohaku's *Pine Forest* (FIG. 28-6), Yosa Buson's *Cuckoo Flying Over New Verdure* (FIG. 28-11), the Dry Cascade and Pools from Saihoji (FIG. 28-2) and the Katsura Imperial Villa (FIG. 28-9)? What do they have in common?

4. Compare Japanese and Chinese ceramics, considering Hamada Shoji's dish (FIG. 28-17), the water jar shown on FIG. 28-8, the Yuan temple vase on (FIG. 27-5) and the Qing dish in FIG. 27-16). What differences do you see and what might account for them? Consider both materials and philosophy.

LOOKING CAREFULLY, DESCRIBING AND ANALYZING

Look carefully at the woodblock print by Harunobu shown FIG.(28-12), and write at least one page analyzing it. Use the following terms: form and composition; material and technique; line and color; space, mass and volume, picture plane.

Here are some questions that might help you with your analysis, but do not be limited by them.

Describe the use of straight lines and curved lines in the setting and in the figures. What shapes do they create? Pay particular attention to the use of pattern, and describe the various patterns that you see. How does the use of pattern relate to the artist's use of the picture plane and to his depiction of pictorial space?

SUMMARY OF JAPAN AFTER 1336

Using the information on page 749 of the text, enter the approximate dates for the following periods.

Muromachi Period:_____ to _____

Momoya Period: _____ to _____

Edo Period: _____ to _____

Modern Japan: _____ to _____

Fill in as much of the chart as you can from memory. Check your answers against the text and complete the chart. Include additional material supplied by your instructor.

	Typical Examples	Stylistic Characteristics	Significant Historical Events, Ideas, etc.
Muromachi Period			
Momoya Period			
Edo Period			
Modern Japan			

29
EUROPE AND AMERICA, 1700-1800

TEXT PAGES 750-774

ROCOCO

1. List four adjectives that describe the type of art created for the
 eighteenth-century French aristocracy:

 a. b.

 c. d.

2. Compare the photographs of the Salon de la Princess of the Hotel de Soubise
 (FIG 29-2) and the Galerie des Glaces de Versailles (FIG. 25-33). List three
 adjectives or phrases that describe each:

 Salon de la Princess Galerie des Glaces
 a. a.

 b. b.

 c. c.

 d. d.

3. One of the best examples of French Rococo architecture, known as the

 was built near Munich, Germany. It was designed by :

 List three Rococo features of this small building:

 a.

 b.

 c.

4. Although the church of Viezehenheiligen retains the energy of Italian Baroque architecture, it shares the following characteristics with the Rococo style:

a.

b.

c.

5. What is a *fête galant*?

6. What two seventeenth-century artists inspired the debate in eighteenth-century France between the advantages of color as the most important element in painting and those of form?

Color: Form:

Which element did Watteau consider to be the most important?

7. List four characteristics of Watteau's *Pilgrimage to Cythera* (FIG. 29-6) that are typical of Rococo art in general:

a.

b.

c.

d.

8. List three Baroque devices used by Boucher in *Cupid a Captive* (FIG. 29-7):

a.

b.

c.

9. In what way does Fragonard's *The Swing* (FIG. 29-1) typify a Rococo "intrigue" picture?

10. Name an Italian painter who created ceiling frescos in the Rococo style:

11. Name a sculptor who worked in The Rococo style:

 List three characteristics of his work:

a.

b.

c.

THE ENLIGHTENMENT

1. What is meant by the "Enlightenment"?

2. Identify the following:

Newton:

Locke:

Diderot:

Voltaire:

3. List two ways in which European art was changed as a result of the scientific and technological advances made from the end of the eighteenth through the early nineteenth centuries?

a.

b.

4. In what ways does Wright of Derby's *Philosopher Giving a Lecture at the Orrery* (FIG. 29-10) reflect the scientific view of the universe?

Would this painting be considered as an appropriate subject for Poussin's "Grand Manner"?

Why or why not?

5. Describe the type of lighting that was often used by Joseph Wright of Derby:

6. What was the significance of the Coalbrookdale bridge?

7. What, according to Rousseau, had corrupted the "natural man"?

How did his views differ from those of Voltaire?

8. What effect did Rousseau's views have on eighteenth-century French art?

9. What sort of scenes did Chardin paint?

10. Sentimentality and moralizing are obvious traits of the work of the French painter:

11. The French painter Elisabeth Louise Vigée-Lebrune specialized in_____.

 In contrast to Rococo artificiality, the style of her self-portrait (FIG. 29-14) can be described as:

12. What type of subject matter did Hogarth portray?

13. Although Gainsborough preferred to paint landscapes, he is best known for his _____.

 Briefly describe his style:

14. For what type of portraits is Sir Joshua Reynolds most famous?

15. Name an American painter who was influential in the Anglo-American school of history painting:

16. How does Copley's portrait of *Paul Revere* (FIG. 29-19) differ from contemporary British and continental portraits?

17. What is a *veduta* painting?

 How were they related to the "Grand Tour"?

NEOCLASSICISM

1. Neoclassicism was stimulated by the excavation of the Roman cities of

_____and _____ in the mid _____.

2. Angelica Kauffmann combined two tendencies in her work. What were they?

 a. b.

3. What is the importance of the subject matter in the *Oath of the Horatii* (FIG. 29-23)?

List two Neoclassical stylistic features that are found in that work:

a.

b.

4. Briefly explain the politics behind David's *Death of Marat* (FIG. 29-24):

5. What provided the inspiration for Soufflot's design for the church of Ste. Genevieve (now the Pantheon) in Paris (FIG. 29-25)?

6. In reaction to Baroque buildings, the restraint of _____ was restated in buildings like Chiswick House (FIG. 29-26).

Chiswick House was designed by _____ and _____.

List four of its stylistic features:

a.

b.

c.

d.

7. What served as the model for the Doric portico in Hagley Park (Fig. 29-27)?

8. Name two buildings that apparently influenced Jefferson's designs for
 Monticello:

 a. b.

9. Why did Jefferson believe that the Neoclasssic style was appropriate for the
 architecture of the new American republic?

10. What reference to the Roman republic can be seen in Hudon's portrait of
 George Washington (FIG. 29-30).

 What reference to the classical world can be seen in Greenough's portrait of
 him (FIG. 29-31)?

 Which portrait do you like best? Why?

DISCUSSION QUESTIONS

1. Compare Fragonard's *The Swing* (FIG. 29-1) with Bronzino's *Cupid, Folly and Time* (FIG 22-44). Although both works have strong erotic overtones, they are very different in their emotional effects. What makes one Rococo and the other Mannerist?

2. Discuss the influence of Palladian classicism on eighteenth-century architecture.

3. Compare Benjamin West's *Death of General Wolfe* (FIG. 29-18) with el Greco's *Burial of Count of Orgaz* (FIG. 23-25). Note stylistic similarities and differences and explain the iconographic features that make one a Baroque painting and the other a product of the Enlightenment.

4. Compare Watteau's *Pilgrimage to Cythera* (FIG. 29-6) with Wright of Derby's *A Lecture at the Orrery* (FIG. 29-10), and Greuze's *Village Bride* (FIG. 29-13). What is the style and the social message of each? Which do you feel is most effective with getting that message across? Why?

5. Select two images that you think illustrate the influence of Voltaire and two that illustrate the influence of Diderot, describe the features of them that reflect their thought.

DESCRIBING, ANALYZING AND RELATING TO A SOCIAL MESSAGE

Look carefully at Hogarth's *Breakfast Scene* from *Marriage `a la Mode* (FIG. 29-15) and David's *Oath of the Horatii* (FIG. 29-23). Both images contain social commentary, yet their messages and their styles are quite different. Write at least two pages analyzing and comparing them. Here are some questions that might help you with your analysis, but do not be limited by them.

First look at the spaces and the figures within them. Describe the architectural setting and any accessories you see. Then look at the figures. How many figures are there, and how do they relate to each other and to the spaces the artist has created? What are the figures wearing and how do the costumes relate to the message the artist is trying to convey? What historical period is each depicting? Look at the poses of the individual figures; what does the pose of each figure tell us about the personality and motivation of that figure?

What was the political background in which each image was created? What style did each artist use and how might the style have been important is the artist's message? Why might one of the artists have used a classical theme while the other created a stage set? What was the social purpose of each image; what was each artist trying to get people to do or think? How effective do you think each artist was?

SUMMARY OF 18th CENTURY PAINTING IN EUROPE & AMERICA

Fill in as much of the chart as you can from memory. Check your answers against the text and complete the chart. Include additional material supplied by your instructor.

	Typical Examples	Stylistic Characteristics	Significant Historical Events, Ideas, etc.
Watteau Country:			
Boucher Country:			
Tiepolo Country:			
Wright of Derby Country:			
Chardin Country:			
Greuze Country:			
Vigee-Lebrun Country:			
West Country:			
Canaletto Country:			
Copley Country:			
Kaufmann Country:			
David Country:			

SUMMARY OF 18th CENTURY ARCHITECTURE & SCULPTURE IN NORTHERN EUROPE

Fill in as much of the chart as you can from memory. Check your answers against the text and complete the chart. Include additional material supplied by your instructor.

	Typical Examples	Stylistic Characteristics	Significant Historical Events, Ideas, etc.
Boffrand Country:			
Cuvilliès Country:			
Asam Country:			
Clodion Country:			
Darby & Prichard Country:			
Adam Country:			
Soufflot Country:			
Boyle & Kent Country:			
Jefferson Country:			
Houdon Country:			
Greenough Country:			

30
EUROPE AND AMERICA 1800 TO 1870

TEXT PAGES 776-818

ART UNDER NAPOLEON

1. For what major patron did David work after the fall of the Revolutionary party?

2. In what ways does the *Coronation of Napoleon* (FIG 30-2) document the relationship between church and state?

 What Neoclassic features are apparent in the painting?

3. What was the original purpose of La Madeleine (FIG. 30-3)?

 What are its primary stylistic features?

4. Which aspect of Canova's portrait of Pauline Borghese (FIG. 30-4) comes from the earlier Rococo style?

 Which aspect is realistic?

 Which features are Neoclassical?

5. Name three of David's pupils:

a. b. c.

6. In what respect does Gros' *Pest House at Jaffa* (FIG. 30-05) differ stylistically from David's *Oath of the Horatii* (FIG. 29-23)?

7. What is the supposed setting for Girodet-Troison's *Burial of Atala* (FIG. 30-06)?

What story does it tell?

8. In breaking with David, Ingres adopted a manner that he felt was based on true and pure Greek style. List two characteristics of that style:

a.

b.

9. What did Ingres use as the model for the composition of his *Apotheosis of Homer* (FIG. 28-7)?

10. Name two Renaissance artists whose influence is apparent in Ingres' *Grande Odalisque (FIG. 30-8):*

a. b.

ROMANTICISM

1. Scholars use the term "Romanticism" to refer to a general phenomenon that began around _____ and ended around _____. It can also be used mare narrowly as the name of a movement that flourished between _____ and _____.

2. The shift from reason to feeling, from objective nature to subjective emotion, is characteristic of the attitude of mind known as:

List three values that were stressed during the so-called Age of Sensibility:

a.

b.

c.

3. What feelings were thought to be evoked by the "sublime" in nature and art?

4. What type of subject matter was typically found in the work of Henry Fuseli?

5. Who was William Blake?

Briefly characterize his style:

6. Goya's work cannot be confined to a single stylistic classification. Briefly summarize his varied concerns as expressed in the following works:

Sleep of Reason Produces Monsters (FIG. 30-11):

The Family of Charles IV (FIG. 30-12):

The Third of May, 1808 (FIG. 30-13):

Saturn Devouring his Children (FIG. 30-14):

7. What was the political message behind Gericault's *Raft of the Medusa* (FIG. 30-15)?

List three devices he used to add drama to his presentation:

a.

b.

c.

8. The portrait shown on FIG. 30-16 illustrates Gericault's interest in

_____.

9. The seventeenth- century debate between the Poussinists and the Rubenists was carried

on in the nineteenth century by _____, the draftsman, and

_____, the colorist.

10. List four characteristics of Delacroix's style that are seen in *The Death of Sardanapalus* (FIG. 30-17):
a.

b.

c.

d.

What does the scene depict and how does the subject relate to the interests of the Romantics?

11. What political event did Delacroix depict in *Liberty Leading the People* (FIG. 30-18)?

12. List three romantic interests embodied in *The Tiger Hunt* (FIG. 30-19):

a.

b.

c.

13. Write down one of Delacroix's observations on the way to apply color to the canvas:

14. What did Rude portray in *La Marseillaise* (FIG. 30-20)?

What similarities do you see to Delacroix's *Liberty Leading the People* (FIG. 30-18)?

What differences?

15. What did Caspar David Friedrich believe that the artist should paint?

16. What sorts of scenes did Constable like to paint?

How did he create the sparkling effect of light?

In what way could his work be related to the Romantic outlook?

17. How does Turner's *Slave Ship* reflect the practices of nineteenth-century slave traders?

List three adjectives that describe Turner's style:

a. b. c.

What features of Turner's work were most influential in liberating artists from the traditional way of painting?

18. To what school of art did Thomas Cole belong?

19. Name two artists who painted views of the landscape of the western United States:

a. b.

What relationship did their paintings have to the doctrine of Manifest Destiny?

REALISM

1. Although hailed as the father of Realism, Courbet did not like to be called a Realist. What can we gather from his statements were his goals as a painter?

What formal qualities distinguish his work?

2. What political views did Courbet illusrate in the *Stone Breakers*?

3. List two features of Courbet's *Burial of Ornans* (FIG. 30-28) that horrified contemporary critis:

 a.

 b.

 How does the work differ from contemporary Romantic works?
4. In what type of subject matter did Millet specialize?

 How was his work viewed by members of the French Middle class?

5. Although Daumier did many fine paintings, he is primarily known for his work in the medium of _____.

 With what type of subject matter was he primarily concerned?

6. In what sort of painting did Rosa Bonheur specialize?

7. *Le Déjeuner sur l'Herbe* (FIG. 30-33), the painting that caused such a scandal at the Salon des Refusés of 1863, was painted by _____.

 Which aspects of the picture shocked the public?

 What was the artist's major concern when he painted the work?

8. What did the public think that Olympia (FIG. 30-34) depicted?

 What technical features contributed to Manet's perceived "audicty"?

9. In what way do the classical figures painted by Bouguereau (FIG. 30-35) differ from those painted by Manet?

10. An important 19th century German realist painter was:

11. In what style did the AmericanWinslow Homer paint?

12. How did the American public receive Thomas Eakins's *Gross Clinic* (FIG. 30-38)?

13. How did Sarget's painting technique differ from that of Eakins?

14. the African-American artist _____ studied with Eakins before moving to Paris. List three characteristics of his style:

 a.

 b.

 c.

15. Name two styles influenced Edmonia Lewis's sculpture?

 a. b.

 What was the political significanceof her sculpture *Forever Free*?

16. List two concerns that were shared by the artists who formed the Pre-Raphaelite Brotherhood.

 a.

 b.

ARCHITECTURE

1. What style did Barry and Pugin use for the rebuilding of the Houses of Parliament in London (FIG. 30-44)?

2. What relationship does the style of Nash's Royal Pavilion in Brighton (FIG. 30-45) have to British Imperialism?

3. List three features that the Paris Opéra (FIG. 30-46) shares with the east façade of the Louvre (FIG. 25-31):

 a.

 b.

 c.

4. Describe the effect of the use of iron on nineteenth-century architectural structures:

5. What was the significance of the techniques used by Paxton to construct the Crystal Palace (FIG. 30-48)?

PHOTOGRAPHY

1. What is the difference between the *camera obscura* and the *camera lucida*?

2. When did Daguerre present his new photographic process in Paris?

 Briefly describe the Daguerrotype process:

3. What is a calotype?

 Who developed it and when?

4. Describe Wet-Plate photography:

5. For what type of work were the following photraphers most famous:

Hawes and Southworth:

Nadar:

Julia Margaret Cameron:

Timothy O'Sullivan:

Edweard Muybridge

DISCUSSION QUESTIONS

1. In what way does Rousseau's statement "Man is born free, but everywhere in chains" reflect the premises of Romanticism? Select three images that you think illustrate this view and explain why they do.

2. Do you think there are remnants of Romanticism alive today in our society? If so, can you identify them? How are they reflected in the arts? What film that you have seen recently best embodies the ideas of romanticism? Can you think of an artist working today that you would consider to be a Romantic?

3. Discuss the differences in approach to the depiction of landscape in the works of Poussin (FIG. 25-25), Ruisdale (FIG. 25-18), Canaletto (FIG. 29-20), Friedrich (FIG. 30-21), Constable (FIG. 30-22), Cole (FIG. 30-24), Bierstadt (FIG. 30-25), and Church (FIG. 30-26).

4. Compare Eakins's *Gross Clinic* (FIG. 30-38) with Rembrant's *Anatomy Lesson of Dr. Tulp* (FIG. 25-12) and Hawes and Southworth's *Early Operation under Ether* (FIG. 30-51). What medium has each used, and how does the medium influence the art work?

5. Compare Manet's *Le Dejeuner sur 'lHerbe* (FIG. 30-33) with Giorgione/Titian's *Pastoral Symphony* (FIG. 22-35). In what ways are they similar, and in what ways do they differ? Why do you think the Parisian public was shocked by Manet's work but considered Giorgioni's work to be a classical masterpiece?

LOOKING CAREFULLY DESCRIBING AND ANALYZING

Write a page comparing Ingres' *Grande Odalisque* (FIG. 30-8) with Titian's *Venus of Urbino* (FIG. 22-40). How do they differ in composition, body type, distortion, and degree of idealization? Here are some ideas that might help you with your analysis, but do not be limited by them. First describe all the objects and forms that appear in each painting. Look carefully at the brush strokes of each artist and describe them noting how apparent the brush strokes are and what sorts of patterns they create, the describe the color that each uses, using the terms hue, intensity and contrast. Describe the underlying composition structures used by both artists. Summarize by noting how these factors contribute to the different emotional impact of the two works.

SUMMARY OF PAINTING IN EUROPE 1800-1870

Fill in as much of the chart as you can from memory. Check your answers against the text and complete the chart. Include additional material supplied by your instructor.

	Typical Examples	Stylistic Characteristics	Significant Historical Events, Ideas, etc.
David Country:			
Gros Country:			
Girodet-Trioson Country:			
Ingres Country:			
Fuseli Country:			
Blake Country:			
Goya Country:			
Guericault Country:			
Delacroix Country:			

SUMMARY OF PAINTING IN EUROPE & AMERICA 1800-1870 (continued)

	Typical Examples	Stylistic Characteristics	Significant Historical Events, Ideas, etc.
Friedrich Country:			
Constable Country:			
Turner Country:			
Leibl Country:			
Homer Country:			
Eakins Country:			
Sargent Country:			
Tanner Country:			
Millais Country:			
Rosetti Country:			

31
EUROPE AND AMERICA 1870 TO 1900

TEXT PAGES 820-851

1. Why is the 3rd quarter of the 19th century refered to as the Second Industrial Revolution?

2. Identify the major contribution of each:

 Karl Marx:

 Charles Darwin:

3. List three nineteenth-century phenomena that the author believes contributed to the greater consciouness of modernity, "the state of being modern."

 a.

 b.

 c.

4. What role did Salons play in nineteenth century France?

IMPRESSIONISM

1. List four characteristics of Impressionism.

 a.

 b.

 c.

 d.

2. Name four painters who could be consider to be Impressionists:

 a. b.

 c. d.

3. Which of the Impressioniss most systematically investigated the roles of light and color in representing atmosphere and coimage?

 List two devices he used to capture the vibrating quality of light:

 a.

 b.

4. In what ways does Monet's *Saint-Lazare Train Station* (FIG. 31-4) reflect the new uban Paris?

 In subject matter?

 In style?

5. What effect did the work of George Hausmann have on Paris, and how does Caillebott's *Paris: A Rainy Day* (FIG. 31-5) reflect it?

6. What other art form did Pissarro use to help him achieve the casual compositions of many of his paintings of Paris?

7. What stylistic features did Berthe Morisot share with other Impressionists?

8. What types of subjects did Renoir prefer to paint?

9. Describe one logical discrepancy used by Manet in *A Bar at the Follies Bergere* (FIG. 31-9) to call attention to the pictorial structure of the painting itself:

10. Define *Japonisme*.

11. In what ways does Degas' work show the influence of Japanese prints?

 a.

 b.

 c.

12. What were Mary Cassatt's favorite subjects?

13. Why did Whistler call his paintings "arrangements" and "nocturnes"?

POST-IMPRESSIONISM

1. List three influences seen in Toulouse-Lautrec's *At the Moulin Rouge* (FIG. 31-14) and describe the features that reflect each influence.

 a.

 b.

 c.

2. Name four major Post-Impressionist painters, noting the aspects of Impressionism that they criticized and how those criticisms were reflected in their work:

a.

b.

c.

d.

3. The French painter who used the work of color theorists like Chevreul and Rood to develop a scientifically precise method of applying paint was _____.

What technique did he develop for applying color to canvas and what did he call it?

4. For Van Gogh, the primary purpose of color in his paintings was:

5. How did Van Gogh apply paint to his canvas, and what type of effect did his application produce?

6. How did Gauguin's use of color differ from Van Gogh's?

7. Where did Gauguin spend the last ten years of his life?

8. Who said, "I want to make of Impressionism something solid and lasting like the art in the museums"?

9. What two roles does color play in Cezanne's paintings?

 a.

 b.

SYMBOLISM

1. By the end of the nineteenth century, what major change had occurred in the artist's vision of reality?

2. What did the Symbolist artists consider to be their primary task?

3. Puvis de Chavannes was admired by members of the Academy because of his

_____while the Symbolist artists admired him because of his

_____ and _____.

4. List three stylistic characteristics of the work of Gustave Moreau.

 a.

 b.

 c.

5. According to Redon, his originality consisted in:

6. The work of Henri Rousseau (FIG. 31-25) can be related to that of the Symbolists through his reliance on dream and fantasy, but his style differes from theirs in the following way:

7. Name an English Symbolist:

8. The major themes in the work of Edvard Munch were:

9. Describe the sensibility associated with the *fin-de-siècle* period:

10. Briefly describe the style of Gustave Klimt:

What features did his work share with the works of the Symbolist painters?

11. What effect did the use of soft focus have on the photographs of Gertrude Kaiserbier?

SCULPTURE

1. What style did Augustus Saint-Gaudens utilize for his monument to Mrs. Henry Adams (FIG. 31-30)?

2. What stylistic influences are most evident in the sculpture of Jean-Baptiste Carpeaux?

3. What concern did Rodin share with the Impressionists?

4. What did the commisioners of the *Burghers of Calais* (FIG. 31-33) find offensive in the work?

ARCHITECTURE AND DECORATIVE ARTS

1. In what country did the Arts and Crafts movement originate?

 What was the goal of the movement?

 What type of objects did its members produce?

2. Name two Scottish artists who practice the ideas of the Arts and Crafts movement:

 Write down two adjectives that describe the designs of husband and wife:

 a. b.

3. The style that developed out of the ideals of the Arts and Crafts movement was given different names in different countries. Write down what it was called:

 in France, Belgium, Holland, England and the United States:

 in Germany:

 in Spain:

 in Italy:

4. What sort of forms were preferred by Art Nouveau artists?

5. List four sources from which Art Nouveau artists drew inspiration:

 a.

 b.

 c.

 d.

6. Name the craftsman whose lavish creations reflected the Art Nouveau style in America:

7. Briefly describe Gaudi's architectural style.

8. When did Eiffel construct his tower in Paris (FIG. 31-1)?

 For what event?

9. What event influenced the technique of encasing iron skeletal structure with masonry?

10. What was the importance of the Marshall Field Warehouse (FIG. 31-39)?

11. Which features of Sullivan's Carson, Pirie, Scott building (fig. 31-41) demonstrate his famous dictum "form follows function?"

DISCUSSION QUESTIONS

1. What characteristics does Courbet share with the Impressionists and in what ways does his work differ significantly from theirs? Should the Impressionists be considered Realists?

2. Compare the family portraits depicted by Tanner (FIG. 30-40), Sargent (FIG. 30-39), Kasebier (FIG. 31-29) and Morisot (FIG. 31-7). Discuss the impression each gives of the relationship between the family members and note the formal elements that the artist used to create that effect.

3. Compare Cezanne's still life on FIG. 31-21 with Willem Kalf's on FIG. 25-22. Note differences in composition, the treatment of color, painting technique and distortion of form.

4. Compare Seurat's *Sunday Afternoon on the Island of La Grande Jatte* (FIG. 31-15) with Renoir's *Le Moulin de la Galette* (FIG. 31-8) and Piero delta Francesca's *Flagellation of Christ* (FIG. 21-43). What characteristics does Seurat's painting share with each?

5. Discuss the main contribution made by each of the major Post-Impressionists. In what ways are their works a continuation of historical artistic traditions?

6. Compare MacIntosh's Tea Room (FIG. 31-35) with the sixteenth-century Japanese Tea House in Kyoto (FIG. 28-7). What attitudes do they share toad craftsmanship and design?

7. Discuss the influence of Japanese woodblock prints on late nineteenth century French painting. Select from Degas' *Ballet Rehearsal* (FIG. 31-10), Degas' *The Tub* (FIG. 31-11), Cassatt's *The Bath* (FIG. 31-12), Lautrec's *At the Moulin Rouge* (FIG. 31-14), and Gauguin's *The Vision After the Sermon* (FIG. 31-18),and Klimt's *The Kiss* (FIG. 31-28) What stylistic features did each artist adopt.

8. In what sense is the slogan "form follows function" accurate or inaccurate as a summary description of the majority of today's architecture? For examples in answering this question, consider buildings in your own community.

LOOKING CAREFULLY DESCRIBING AND ANALYZING

Write at least one page and a half comparing Van Gogh's *Starry Night* (FIG. 31-17) with Monet's *Impression Sunrise* (FIG. 31-2). Here are some ideas that might help you with your analysis, but do not be limited by them. First describe all the objects and forms that appear in each painting. Look carefully at the brush strokes of each artist and describe them noting how apparent the brush strokes are and what sorts of patterns they create, the describe the color that each uses, using the terms hue, intensity and contrast. Describe the underlying composition structures used by both artists. Summarize by noting how these factors contribute to the different emotional impact of the two works.

SUMMARY OF PAINTING IN EUROPE 1870-1900

Fill in as much of the chart as you can from memory. Check your answers against the text and complete the chart. Include additional material supplied by your instructor.

	Typical Examples	Stylistic Characteristics	Significant Historical Events, Ideas, etc.
Monet Style: Country:			
Cailbotte Style Country:			
Pissarro Style: Country:			
Morisot Style: Country:			
Renoir Style: Country:			
Manet Style: Country:			
Degas Style: Country:			
Cassatt Style: Country:			
Whistler Style: Country:			
Toulouse-Lautrec Style: Country:			

SUMMARY OF PAINTING IN EUROPE 1870-1900 (continued)

	Typical Examples	Stylistic Characteristics	Significant Historical Events, Ideas, etc.
Seurat Style: Country:			
Van Gogh Style: Country:			
Gauguin Style: Country:			
Cezanne Style: Country:			
Puvis de Chavannes Style: Country:			
Moreau Style: Country:			
Redon Style: Country:			
Rousseau Style: Country:			
Beardsley Style: Country:			
Munch Style: Country:			
Klimt Style: Country:			
Kasebier Style: Country:			

32
NATIVE ARTS OF THE AMERICAS AFTER 1300

TEXT PAGES 852-869

MESOAMERICA

1. Who succeeded the Zapotecs at Monte Alban:

 At what art form did they excel?

2. What is the Borgia Codex?

3. Where did the Aztecs establish their capital and what was it called?

 Describe the layout of the city:

 What was the center of the city?

 What did it symbolize:

4. What myth is represented by the dismembered corpse shown in FIG. 32-4?

 Describe its stylistic attributes.

5. Identify:

Coatlicue

Cortez

Moctezuma

SOUTH AMERICA

1. The capital of the Înka empire was:

2. Why did the Inkas control clothing pattern and style?

3. What was the function of a khipu (*quipue*)?

4. For what characteristics is Inka architecture most famous?

5. What is the major significance of Machu Picchu?

6. How was the Temple of the Sun in Cuzco constructed and decorated (FIG. 32-7)?

NORTH AMERICA

1. Briefly identify the following:

 Kiva

 Anastazi

 Katsina

2. The builders of the great complexes at Chaco Canyon and the Cliff Palace are known as the:

 They decorated the kiva of the Kuaua Pueblo with mural paintings representing:

3. Name two later groups that belong to the so-called "Pueblo Indians":

 a. b.

4. Name two nomadic groups who migrated into the Southwest sometime between 1200 and 1500:

 a. b.

5. What was the purpose of Navajo sand painting?

6. List one effect on Navajo weaving that was the result of the arrival of tourists in the 1800s:

7. For what was Maria Martinez famous?

8. List two purposes of masks carved by Northwest Coast artists:

 a.

 b.

9. Haida house frontal or "totem" poles serve as expressions of:

 List three types of figures that may be included in such poles:

 a.

 b.

 c.

10. What is the function of a Chilkat blanket?

 Who designed them?

 Who wore them?

11. List some recurrent stylistic characteristics found in objects created by the historic inhabitants of the Northwest Coast:

a.

b.

c.

d.

12. What of the following elements of the Yupik Eskimo mask shown in FIG. 32-15 symbolize?

Face:

Hoop:

Paired human hands:

Rattling appendages:

White spots:

13. To what do the pipe, painted buffalo robe and bearclaw necklace shown in Bodmer's portrait of *Two Ravens* (FIG. 32-16) refer?

14. Name two art forms of Plains Indians that flourished during the so-called "reservation period."

a.

b.

DISCUSSION QUESTIONS

1. What similarities can you find between the social structures of pre-Columbian America and those of Egypt and the ancient Near East? In what ways do you think the art forms of the various cultures were influenced by their social structures?

2. What do the images illustrated in FIGS. 32-4 and 32-5 tell us about Aztec religion?

3. Discuss the different building techniques and architectural decoration used by Mayan (FIG. 14-10) and Peruvian architects (FIG. 32-1 and 32-7).

4. Compare the style and organization of the kiva mural on FIG. 32-8 with that of the animal paintings from Lescaux (FIG 1-11) and with Mantegna's fresco from the *Camera degli Sposi* (FIG. 21-47 and 21-48). What type of pictorial organization is used in each? Which type does the kiva painting resemble most closely? Why? What social role did each of the images play?

5. Discuss the role that clothing played in defining status in pre-Columbian and Native American society. Consider the Chilkat blanket in FIG. 32-14, the Hidatsa warrior shown on FIG. 30-16, and the women from the Ledger Book shown in FIG. 30-17.

6. Discuss the role of dance and masking among Native Americans by comparing the masks on FIGS. 32-11, 32-12 and 32-15 with the Katsina figure shown on FIG. 32-9.

LOOKING CAREFULLY, DESCRIBING AND ANALYZING

Look carefully at the figure of Coatlicue on FIG. 32-5, and write at least one page analyzing it. Use the following terms: material and technique; form and composition; line and pattern; mass and volume. Here are some questions that might help you with your analysis, but do not be limited by them.

How large is the figure? Do you think the figure was designed to be seen frontally or from the side? What material was used to create it and how might the material have influenced the form? Carefully describe each part, starting from the head and working down. What type of creature might have served as a model for each part? Note the patterns that the artist has created, and observe which seem to be derived from the creatures that inspired it. What do you think the sculpture was intended to signify, and how might the various parts have helped to put across that meaning?

141

NATIVE ARTS OF THE AMERICAS AFTER 1336

Fill in as much of the chart as you can from memory. Check your answers against the text and complete the chart. Include additional material supplied by your instructor. Write down the region were each is located.

	Typical Examples	Stylistic Characteristics	Significant Historical Events, Ideas, etc.
Mixteca-Puebla Region:			
Aztec Region:			
Inka Region:			
Ancestral Puebla Region:			
Apache Region:			
Hopi Region:			
Martinez Region:			
Kwakiutl Region:			
Tlingit Region:			
Haida Region:			
Yupik Region:			
Hidatsa Region:			
Ledger Paintings Region:			

33
OCEANIA

PAGES 870-887

1. Name the three cultural areas of Oceania:

 a. b. c.

2. What are the oldest dates assigned to human populations in Australia and New Guinea?

AUSTRALIA AND MELANESIA

1. What is the focus of many of the myths of aboriginal Australians?

2. Describe the "X-ray" style of Auuenau painting shown on FIG. 33-2:

3. What stylistic characteristics of aboriginal are seen in the work of Emily Kame Kngwarreye on FIG. 33-3?

4. List three factors which played a significant role in Asmat art and society:

 a.

 b.

 c.

5. What was the purpose of the poles shown on FIG. 33-4?

6. Describe the male and female powers symbolized on the Iatmul ceremonial house shown on FIG. 33-5:

 Who might enter the house?

7. What role did art play in the Hevehe cycle practiced by the Elema?

8. What art form is associated by the Abelam with the yams?

9. What is a Malanggan and what did it symbolize?

10. List three stylistic characteristics of the Tatanua mask shown on FIG. 33-8.

 a.

 b.

 c.

 Of what materials was it made?

11. List three motifs that appear on the prows of Trobriand boats (FIG. 33-9) and note what they symbolized:

a.

b.

c.

MICRONESIA

1. What is the essential focus of life and art for Micronesian peoples?

2. Briefly describe the style of the prow decoration depicted on FIG. 33-10:

3. What is the function of the "storyboards" depicted on the Men's ceremonial house in Belau (FIG. 33-11)?

4. List three of the meanings associated with Dilukai figures like the one shown on FIG 33-12?

a.

b.

c.

How does the representation relate to the role of women in Oceania?

POLYNESIA

1. What role did art objects play in upholding Polynesian social structure?

2. Identify the following terms:

 mana

 moai

 tapa

 tiki

3. Briefly describe the moai of Easter Island?

4. Who traditionally created the bark cloth that was so popular in Polynesia?

 What is it commonly called?

 What was it used for?

5. Why do we know so little of the meaning of Rorotongan deities like the one represented on FIG. 33-15?

6. What was the purpose of the tattoos that was so popular in Polynesia?

What stylistic tendencies of Polynesian art are represented by tattoo patterns?

7. List three characteristics of Polynesian art as seen in the image of Kukailimoku (FIG. 33-19):
 a.

 b.

 c.

8. What purposes of Polynesian art were shared with the Maori peoples of New Zealand?

How were these purposes illustrated in the meeting house shown on FIG. 33-20?

DISCUSSION QUESTIONS

1. Discuss the symbolism of life and death seen in the bisj pole (FIG. 33-4), the Iatmul ceremonial house (FIG. 33-5), the fresco from Teotihuacan (FIG. 14-7), the Aztec figure of *Coatlicue* (FIG. 30-4), the *Dancing Shiva* (FIG. 6-17), the grave stele of Hegeso (FIG. 5-57), the *Last Judgment* from Autun (FIG. 17-12), and Signorelli's *Damned cast into Hell* (FIG. 21-41)While there is a common human concern behind these images, the representations are quite different. What does each tell us about attitudes toward death expressed by the various cultures. In what way does the style of each intensify the message?

2. Discuss the variety of styles found in Oceania by comparing the bisj poles from New Guinae (FIG. 33-4), the maoi from Easter Island (FIG. 33-1), the dikulai from Belau (FIG. 33-11), the Kuka'ilimodu from Hawaii (FIG. 33-19), the canoe prow from the Trobriands (FIG. 3-9), and the Australian *auuenau* (FIG. 33-2). Which do you like best? Why?

3. What similarities and what differences do you see between the Cliff Whiting's Tahiri-Matea (FIG. 33-21), the tattooed warrior from the Marquesas (FIG. 33-17), the Umayyad palace (FIG. 13-7), the Merovingian fibula (FIG. 16-2), the carpet page from the *Lindesfarne Gospels* (FIG. 16-1), and the *Book of Kells* (FIG. 16-8). What design principles does each use? What function does the decoration play in the meaning of each?

4. What role do the ancestors play in each of the following: the Asmat bisj pole (FIG. 33-4), the Iatmul men's house (FIG. 33-5), the Northwest Coast pole (FIG. 32-13), the *Benin Royal Shrine* (FIG. 34-11), and the *Augustus of Primaporta* (FIG. 10-27).

LOOKING CAREFULLY, DESCRIBING AND ANALYZING

Look carefully at the Tatanua mask shown on FIG. 33-8, and write at least one page analyzing it. Use the following terms: material and technique; form and composition; line and pattern; mass and volume. Here are some questions that might help you with your analysis, but do not be limited by them. How large is the mask? Carefully describe each part of the mask, noting the material that was used and the forms and patterns that were created with it. How might the material have influenced the form? How many colors do you see? Do you think all the colors derive from the natural materials or were they painted on?

After you have analyzed the mask visually go to the text and determine how the mask was used as what they represented. What emotional effect is created by the mask and how effective would have been in fulfilling its purpose?

OCEANIA

Fill in as much of the chart as you can from memory. Check your answers against the text and complete the chart. Include additional material supplied by your instructor. Write down the region were each is located.

	Typical Examples	Stylistic Characteristics	Significant Historical Events, Ideas, etc.
Australia Region:			
Asmat Region:			
Iatmul Region:			
Elema Region:			
Abelam Region:			
Trobriand Islands Region:			
Carolina Islands Region:			
Easter Island Region:			
Tonga Region:			
Haida Region:			
Roatanga Region:			
Marquesas Islands Region:			
Hawaii Region:			
Maori Region:			

34
AFRICA AFTER 1800

TEXT PAGES 888-907

1. What do the rock paintings of the San people often depict?

2. What was the common function of figures like those shown on
FIGS. 34-1, 34-3 and 34-4?

3. What materials were used to create the throne shown on FIG. 34-5?

What feature indicates that this was done after contact with Europeans?

4. What was the purpose of Kongo figures like the one represented on FIG. 34-7?

Give three adjectives or phrases that describe its style:

a.

b.

c.

5. How were power figures like the one shown in FIG. 34-8 activated?

6. List four activities that figures like this could control:

a.

b.

c.

d.

7. What was the purpose of Dogon carvings like the one illustrated in FIG. 34-9?

How does the artist treat the human body?

Why might the image called "conceptual" rather than "perceptual?"

8. Where were Baule figure sculptures like the ones on FIG. 34-10 usually kept?

9. Give the meaning of the following terms from the Benin royal ancestor altar on FIG. 34-11?

King's head:

Elephant tusk:

Rattle staffs:

Pyramidal bells:

What was usually the central sculpture of such shrines?

10. List four arts that were traditionally done by men:

a.

b.

c.

d.

List three that were traditionally done by women:

a.

b.

c.

11. Name two well-known 20th century African sculptors and briefly characterize the style of each.

a.

b.

12. Describe the social function of African masquerades:

13. List five creatures whose features are combined in the masquerader shown on FIG. 34-15:

a.

b.

c.

d.

What is the purpose of such costumes?

14. What does a Senufo mask like the one shown on FIG. 34-16 represent?

Who wore such masks?

15. What legend is being depicted in the Dogon Satimbe mask shown in FIG. 34-17?

16. What female ideals are symbolized by the following features of Mende masks (FIG. 34-18)?

High broad forehead:

Intricately plaited hair:

Small closed mouth:

Downcast eyes:

How are these masks used?

17. What type of materials did the Kuba typically use to crate their masks and costumes?

18. What role did costume and adornment play for the Kuba kings as shown in FIG. 34-21?

19. What role do costume and adornment play among the Sanburu of Kenya?

20. What is a Mbari house?

21. Identify the following:

Togu na

Ga coffins

22. What traditional concept does Trigo Piula integrate into the 20th century painting shown in FIG. 34-26?

23. What is the political meaning of Willie Boster's *Homage to Steve Biko*?

24. Describe an important change in the function of African arts during the past 50 to 100 years:

DISCUSSION QUESTIONS

1. Discuss the role of the ancestors in the traditional spiritual life of Africa, Including the art forms and rituals that are used to evoke them. Select four images to illustrate your argument.

2. How do the roles of art and the artist differ in African groups as compared with those in European and Oriental cultures?

3. Describe briefly the function of masks in the cultures of Africa, Oceania and among Native Americans in North America. What similarities and what differences do you see. Select two examples from each area to illustrate your discussion.

4. Discuss the costumes and accessories used by African rulers to symbolize their power. Select appropriate images from both chapters 15 and 34 to illustrate your discussion.

LOOKING CAREFULLY, DESCRIBING AND ANALYZING

Look carefully at the photograph of the Kuba king shown on FIG. 34-21, and the painting of King Louis XIV shown in FIG. 25-30. Write at least one page analyzing and comparing the images, focusing on the role that adornment plays in signifying royalty. Here are some questions that might help you with your analysis, but do not be limited by them. Describe the setting and the position of the each king. What accessories do you see in each picture? What symbols of power can you find in each image? What is each king wearing? How many different materials and patterns can you see in each image? In what way to these enhance the projected power of the ruler. What type of clothing do contemporary rulers wear? What does that say about their claim to power and their relation to their people?

As an alternative to this assignment, you could design a costume for a contemporary ruler that would project his or her power in the same way that these two kings do and write up an explanation of the various symbols you use.

AFRICA AFTER 1800

Fill in as much of the chart as you can from memory. Check your answers against the text and complete the chart. Include additional material supplied by your instructor.

	Typical Examples	Stylistic Characteristics	Significant Historical Events, Ideas, etc.
Fang			
Kota			
Kalabari Ijaw			
Bamun			
Fon			
Kongo			
Dogon			
Baule			
Benin			
Asante			
Senufo			
Mende			
Kuba			

AFRICA AFTER 1800: NAMED ARTISTS AND OBJECTS

Fill in as much of the chart as you can from memory. Check your answers against the text and complete the chart. Include additional material supplied by your instructor.

	Typical Examples	Stylistic Characteristics	Significant Historical Events, Ideas, etc.
Kendo			
Osei Bonsu			
Olawi of Ise			
Trigo Piula			
Willie Bester			
Paa Joe			
Kane Kwei			
Mbari Houses			
King Kot A-Mbweeky			
Togu na			

35
EUROPE AND AMERICA, 1900-1945

TEXT PAGES 908-967

1. Give the approximate dates for the folowing significant twentieth-century events thatinfluenced art as well as the rest of society:

World War I:

Russian Revolution:

The Great Depression:

World War II:

EUROPE 1900-1920

1. What general direction was taken by many avant-garde artists in response to the turmoil?

2. What is meant by the term "Expressionism"?

3. In what year was the exhibition held in which the name "Fauve" was coined?

 What did it mean?

4. Name two Fauve painters.

 a. b.

 Describe the characteristics that Fauve paintings have in common.

5. Name two artists who belonged to *Die Brucke* (The Bridge).

 a. b.

 Why did they select the name *Die Brucke?* What did it signify?

 Name three sources for their art.

 a.

 b.

 c.

6. What effect did the work of Max Plank, Albert Einstein, Ernest Ruthurford and Neils Bohr have on the existing faith in objective reality?

 What effect did it have on art in the early 20th century?

7. What beliefs were shared by members of the Blue Rider *(Die Blau Reiter)* group?

 Name two artists who belonged to this group.

 a. b.

8. In what medium did Kathe Kollwitz do most of her work?

 What social class did she most often depict?

9. Name a German Expressionist sculptor:

10. Who was Gertrude Stein and what was her significance for the avant-garde of Paris?

Who painted a famous portrait of her?

11. Identify three probable sources of the dislocation of form seen in Picasso's
 Demoiselles d'Avignon (FIG. 35-12).
 a.

 b.

 c.

12. Name two Cubist painters.

 a. b.

 What idea did the Cubists adopt from Cezanne?

13. What is the basis of Cubist pictorial space, and how does it differ from
 Renaissance perspective?

14. What is Orphism and who was its founder?

15. How does Synthetic Cubism differ from Analytic Cubism?

16. What is a collage?

17. Name three sculptors whose abstracted froms derive from the experiments of the Cubists:

 a. b. c.

18. What new material and technique did Julio Gonzalez contribute to modern sculpture?

19. How did Fernand Leger modify Cubist practices?

20. What were the Futurists trying to express in their art?

21. Name two Futurist painters:

 a. b.

 Name one Futurist sculptor:

22. How did the attitude of the Dadaists toward war differ from that of the Futurists:

23. What was the original purpose of the Dada movement?

24. What did the Dadaist derive from the thinking of Sigmund Freud and Karl Jung?

25. Although short-lived, Dadaism had important consequences for later art. What were they?

26. Name four artists connected with the Dada movement.

 a. b.

 c. d.

27. How did Jean Arp utilize chance in his work?

28. What is a readymade?

 Who developed them?

29. Describe a "photomontage"

 Who developed the technique?

30. What did Schwitters mean by the term *merz*?

31. List two barriers to women becoming recognized artists which had been removed by the 20th century:

 a.

 b.

32. List two contributions thaat Gertrude Vanderbilt Whitney made to the art world:

 a.

 b.

33. What sort of art was collected by Peggy Guggenheim?

34. Who were The Eight and what type of painting did they do?

35. Where and when was the Armory show held and what was its significance?

36. Name an influenctial work that was exhibited at the Armory show which particularly shocked the public:

 What was so upsetting about it?

37. In what way did the work of Man Ray express the ideas of Dada?

38. Name two American artists who were influenced by Cubism:

 a. b.

39. What was the Harlem Renaissance?

40. List two traits shared by the so-called Precisionists, one thematic, one stylistic:

 a.

 b.

 Name two artists who are considered Precisonists:

 a. b.

41. Although the artist_____ was first associated with the Precisionists in New York, she is best known for her work in New Mexico.

 Two of her favorite subjects were _____ and
 _____.

 Describe her style:

42. Who was the founder of the Photo-Secession group and Gallery 291?

 What type of photography did he practice?

43. The American photographer who was interested in photographic abstraction was:

EUROPE 1920 TO 1945

1. Who said "Painting is not meant to decorate apartments. It is an instrument for offensive and defensive war against the enemy"?

 How is this statement reflected in his painting of Guernica (FIG. 35-41)?

 What event inspired the painting?

 What symbols did the artist use to refer to the event, and how did he emphasize its horror?

2. What was the purpose of *Neue Sachlichkeit* artists?

 List three artists associated with the movement:

 a. b. c.

3. For what type of subject is George Grosz most famous?

4. List three adjectives that describe the style of Max Beckmann:

 a. b. c.

5. What mood did Otto Dix create in his *War Triptych* (FIG. 35-44)?

 What stylistic characteristics help to create the mood?

6. How does Barlach's war memorial in Güstrow Cathedral (FIG. 35-45)?differ from traditional war memorials?

7. What was the purpose of the Degenerate Art Exhibition that was mounted in Berlin in 1937?

8. According to Andre Breton, what was the purpose of the Surrealist movement?

9. List two techniques used by Surrealist artists to free their creative processes.

 a.

 b.

10. Who was the major practitioner of the style known as *pittura metafisica*?

 Describe the mood created with works like the one shown in FIG. 35-46:

11. Name three painters connected with the Surrealist movement, and note what makes their work distinct.

 a.

 b.

 c.

12. What materials did Oppenheim combine in *Object* represented on FIG. 35-51?

13. Many artists share the surrealist interest in fanasy, even though they were not formally associated with the group. However, Andre referred to one of them as "the most Surrealist of us all." To whom did he refer?

14. Who said "Art does not reproduce the visible; rather it makes visible."?

What did this artist mean by that statement?

15. What did Malevich believe to be the supreme reality?

What type of forms did he use to express that reality?

16. Why did Naum Gabo call himself a "Constructivist"?

List three new materials used by Naum Gabo.

a. b. c.

17. What basic colors and forms characterize Mondrian's mature work?

What did they symbolize for him?

18. What type of form did Brancusi believe was "the most real"?

19. What do the sculpture of Brancusi and Barbara Hepworth's have in common?

20. List three characteristics of the sculpture of Henry Moore.

 a.

 b.

 c.

 What was the most recurrent theme in his work?

21. What is the political significance of Vera Muhina's sculpture shown on FIG. 35-60)?

AMERICA 1930-1945

1. Name six european artists who came to America because of the political chaos of Europe during World War II:

 a. b. c.

 d. e. f.

2. What is a mobile?

 Who invented them?

3. What was the WPA and what was its effect on the arts?

4. The American woman photographer whose work brought the nation's attention to the plight of the rural poor was:

5. Ben Shahn created strong social statements by combining two different types of art. What were they?

a.

b.

6. What is the dominant mood of Hopper's *Nighthawks* (FIG. 35-63)?

7. What were the favorite subjects of Jacob Lawrence?

8. Name two American artists who were associated with the Regionalist School:

a. b.

What type of subjects did they paint?

9. What was the theme of much of Orozco's work?

In what medium did he do most of his work?

10. Why did Diego Rivera want to work in a simple, easily accessible style?

List three aspects of that style:

a.

b.

c.

11. What type of subject matter did Frida Kahlo prefer?

ARCHITECTURE

1. What purpose did Vladimir Tatlin intend *his Monument to the Third International* to serve?

2. Who designed the Schröder House (FIG. 35-71)?

 What style does it reflect?

3. What was the Bauhaus?

 Who founded it?

4. Summarize Gropius' design princes that were incorporated into the Bauhaus?

 a.

 b.

 c.

 d.

5. Name a designer who taught at the Bauhaus noting the type of work he did:

 Name a painter who taught at the Bauhaus:

6. List three characteristics of Mies van der Rohe's architectural style that are found in International Style architecture.

 a.

 b.

 c.

What did Mies van der Rohe mean by "less is more"?

7. Why was the Bauhaus closed and who closed it?

What effect did its closure have on the spread of Bauhaus design principles?

8. Who defined a house as a "machine for living"?

9. How does Courbusier's Villa Savoye (FIG. 35-75) differ from Wright's houses (FIGS. 35-77 to 35-79)?

10. List four stylistic characteristics of the Art Deco style:

 a.

 b.

 c.

 d.

Name one building that illustrates the style:

11. How was Frank Lloyd Wright's concern for "organic" form reflected in his buildings?

List two houses he designed:

a. b.

DISCUSSION QUESTIONS

1. Compare the use of mass, space, and decorative detail in the Villa Rotonda (FIG. 22-29), Chiswick House (FIG. 29-26), the the Schroder house (FIG. 35-71), and the Kaufmann House (FIG. 35-79). Which do you like best? Why?

2. Discuss the effect of so-called "primitive art" on European artists of the early 20th century. What relation did it have to colonialism?

2. The artist Maurice Denis stated that "a picture before being a war horse, a nude woman, or some anecdote, is essentially a plane surface covered with colors assembled in a certain order" How does his view differ from the traditional one regarding the meaning and purpose of a painting? Which artists that you have studied do you thinkwould agree with him? Why?

3. In what ways does the work of Kollwitz (FIG. 35-9), Barlach (FIG. 35-45), Dix (FIG. 35-44), and Beckmann (FIG. 35-43), relate to that of Grunewald(FIGS. 23-2), Altdorf (FIG. 23-8), Baldung Grien (FIG. 23-3), and the medieval *Pieta* on FIG. 18-51? Which do you think their work most esembles? Do you think there are any consistent "German" characteristics?

4. Relate Picasso's statement "I paint forms as I think them, not as I see them," to Egyptian and to Renaissance painting. Which type is closest? Why? How does the Cubist conception of space differ from that held during the Renaissance?

5. Concern with soceal issues is apparent in the work of many twentieth century artists, including Picasso (35-41), Mukhina (FIG. 35-60), Lawrence (FIG. 35-64), Beckmann (FIG. 35-43), Kollwitz (FIG. 35-9), Lange (FIG. 35-62), Orozco (FIG. 35-67), Tatlin (FIG. 35-70), and Barlach (FIG. 35-45). Identify the issue that was addressed in each work and the stylistic means the artist used to express that concern. Which do you think is most effective?

6. Compare Boccioni's *Unique Forms of Continuity in Space* (FIG. 35-24) with the *Nike of Samothrace* (FIG. 5-82) and describe the basic differences between the two works as well as thesimilarities.

7. Compare Brancusi's *Bird in Space* (FIG. 35-57) with Gabo's *Column* (FIG. 35-55). In what ways are the forms similar, and in what ways are they different? How does each artist explain the techniques and goals of his art?

8. Discuss the role of chance in both the Dada and Surrealist movements. What connection do you see between the Dada movement and art movements today?

9. Discuss the aesthetic that developed at the Bauhaus, selecting five images done by Bauhaus faculty to illustrate your discussion. What effects of their influence do you see in contemporary life?

LOOKING CAREFULLY, DESCRIBING AND ANALYZING

Look carefully at two 20th century depictions of war, one by Otto Dix, shown on FIG. 35-44, the other by Picasso on FIG. 35-41, and write at least one page analyzing and comparing them. Use the following terms: size and scale: form and composition; material and technique; line and color; mass and volume, picture plane and distortion. Here are some questions that might help you with your analysis, but do not be limited by them.

First look at the shape, size and scale of each image. In what way to these relate to earlier images? Which image seems to be most traditional? What type of composition does each use? Examine each of the panels in the Dix image and describe what you see in each. Describe each of the figures in the Picasso and note how they are related to each other. How does each artist handle space and the picture plane? What war is each depicting? What distortions does each artist use to express the horror of the events? Which do you think is most effective?

173

SUMMARY OF PAINTING & PHOTOGRAPHY IN EUROPE & AMERICA
1900-1945

Fill in as much of the chart as you can from memory. Check your answers against the text and complete the chart. Include additional material supplied by your instructor.

	Typical Examples	Stylistic Characteristics	Significant Historical Events, Ideas, etc.
Matisse Style: Country:			
Derain Style: Country:			
Kirchner Style: Country:			
Nolde Style: Country:			
Kandinsky Style: Country:			
Marck Style: Country:			
Kollwitz Style: Country:			
Picasso Style: Country:			
Braque Style: Country:			
Delaunay Style: Country:			

SUMMARY OF PAINTING & PHOTOGRAPHY IN EUROPE & AMERICA
1900-1945 (continued)

	Typical Examples	Stylistic Characteristics	Significant Historical Events, Ideas, etc.
Leger Style: Country:			
Balla Style: Country:			
Severini Style Country:			
Arp Style: Country:			
Hoch Style: Country:			
Schwitters Style: Country:			
Sloan Style: Country:			
Hartley Style: Country:			
Davis Style: Country:			
Demuth Style: Country:			
Douglas Style: Country:			
O'Keefe Style: Country:			
Steiglitz Style Country:			

SUMMARY OF PAINTING & PHOTOGRAPHY IN EUROPE & AMERICA
1900-1945 (continued)

	Typical Examples	Stylistic Characteristics	Significant Historical Events, Ideas, etc.
Weston Style: Country:			
Grosz Style: Country:			
Beckmann Style: Country:			
Dix Style: Country:			
De Chirico Style: Country:			
Ernst Style: Country:			
Dali Style: Country:			
Magritte Style: Country:			
Miro Style: Country:			
Klee Style: Country:			
Malevich Style: Country			

SUMMARY OF PAINTING & PHOTOGRAPHY IN EUROPE & AMERICA
1900-1945 (continued)

	Typical Examples	Stylistic Characteristics	Significant Historical Events, Ideas, etc.
Mondrian Style: Country:			
Hopper Style: Country:			
Lange Style: Country:			
Lawrence Style: Country:			
Wood Style: Country:			
Benton Style: Country:			
Rivera Style: Country:			
Orozco Style: Country:			
Kahlo Style: Country:			

SUMMARY OF SCULPTURE, & ARCHITECTURE IN EUROPE & AMERICA
1900-1945

Fill in as much of the chart as you can from memory. Check your answers against the text and complete the chart. Include additional material supplied by your instructor.

	Typical Examples	Stylistic Characteristics	Significant Historical Events, Ideas, etc.
Lembruck Style: Country:			
Lipchitz Style: Country:			
Archipenko Style: Country:			
Gonzalez Style: Country:			
Boccioni Style: Country:			
Duchamp Style: Country:			
Man Ray Style: Country:			
Barlach Style: Country:			
Oppenheim Style: Country:			
Gabo Style: Country:			

	Typical Examples	Stylistic Characteristics	Significant Historical Events, Ideas, etc.
Brancusi Style: Country:			
Hepworth Style: Country:			
Moore Style: Country:			
Muhina Style: Country:			
Calder Style: Country:			
Tatlin Style: Country:			
Reitveld Style: Country:			
Gropius Style: Country:			
Breuer Style: Country:			
Mies van der Rohe Style: Country:			
Le Corbusier Style: Country:			
Wright Style: Country:			

36
EUROPE AND AMERICA AFTER 1945

TEXT PAGES 968-1025

PAINTING AND SCULPTURE 1945-1970

1. What is the attitude of Existentialists toward human existence?

 List three artists whose work reflects these ideas:

 a. b. c.

2. In what way does the sculpture of Giacometti, like the figure shown on
 FIG. 36-2, relate to the ideas of the Existentialists?

3. Name the artist who referred to his art as "an attempt to remake the violence
 of reality itself":

4. List two characteristics of the art of Jean Dubuffet:

 a.

 b.

5. What is "art brut"?

6. List two characteristics of so-called "Greenbergian formalism":

 a.

 b.

7. What major artistic style developed in the United States after the influx of
 refugee artists from Europe?

 In what city did it begin?

8. List two lines that developed out of Abstract Expressionism:

 a. b.

9. Describe the way Jackson Pollock created his "gestural" Abstract Expressionist pieces.

10. List one way in which de Kooning's work relates to that of Pollack:

 List one way in which it differs:

11. What do the works of Barnett Newman and Mark Rothko have in common?

12. Describe the function of Barnett Newman's "zips."

13. What feelings did Mark Rothko hope to evoke with his large, luminous canvases?

14. How does Post-Painterly Abstraction differ from Abstract Expressionism?

15. Why was Ellsworth Kelly's work known as "Hard Edge Abstraction"?

16. What is Color-Field painting?

17. Describe Frankenthaler's soak-stain technique.

What effect did she want to achieve with it?

Name one other artist who utilized it:

18. In what way are the principles of Post-Painterly Abstraction related to Minimalist sculpture?

19. Name two Minimalist sculptors:

a. b.

20. In what way did David Smith's sculpture like the one on FIG. 36-14 differ from Minimalist works?

21. What beliefs about art did Donald Judd assert in works like the forms illustrated in FIG. 36-16?

22. What type of art did Louise Nevelson create?

23. How does the work of Louise Bourgeois' Post-Minimalist work differ from the work of Judd and other artists of the Minimalist school?

24. What was Eva Hesse trying to achieve with her art?

What materials did she use?

What sorts of forms did she create?

25. What subject matter was characteristic of Pop Art of the 1960s?

26. Name an artist who worked in the Pop mode in England:

27. Give an example of Jasper Johns' "things seen but not looked at:"

28. What are "combine" paintings?

 Who developed them?

29. What distinguishes the works of Robert Rauschenberg from those of earlier Dada artists?

30. What did Lichtenstein utilize as the basis of works like the one shown on FIG. 36-23?

 How do his "benday dots" reflect the source?

31. How did Andy Warhol utilize his background as a commercial artist in creating "fine art" works?

32. Name the artist who created designs for gigantic monuments depicting ordinary objects:

33. Name two Surperrealist painters:

a. b.

34. What type of art did Duane Hanson create?

PAINTING AND SCULPTURE SINCE 1970

1. In rejecting the notion that each art work contains a fixed meaning, Postmodern artists are influenced by the ideas of _____theorists.

2. List two important theorists of Deconstructionism:

a. b.

What do Deconstructivists try to reveal?

3. Why is Susan Rothenberg characterized as a Neo-Expressionist?

4. Briefly characterize the style of Julian Schnabel:

His work has been considered as a restatement of the _____ style.

5. What theme is seen in many of Anselm Kiefer's works?

6. Name two artists who consider themselves to be feminist artists.
a. b.

7. Who designed *The Dinner Party* (FIG. 36-33)?

What was it designed to celebrate?

What techniques were used to create it?

8. For what type of art is Miriam Shapiro most famous?

What did she mean by the name "femmage"?

9. Who produced a series of film stills in which she transformed herself (FIG. 36-35)?

What issue was of primary concern to the artist?

10. To what issues does Barbara Kruger want her art to draw attention?

11. Name the artist whose works constituted "a dialogue between the landscape and the female body"?

What feelings do her works evoke?

12. Who are the Guerrilla Girls and what is their agenda?

13. What issue is of major concern to Kiki Smith?

14. Name three artists who used their art to explore issues involved with being African American women:

a. b. c.

15. What issue did Melvin Edwards explore in works like *Tambo* (FIG. 36-43)?

16. Why did Ofili's *Holy Virgin Mary* (FIG. 36-44) elicit such a strong reaction?

17. What is the centerpiece of David Hammon's *Public Enemy* (FIG. 36-45)?

 What was the purpose of the work?

18. Name a Native American artist who uses cultural heritage and historical references to comment on the present:

19. List three stylistic features of Leon Golub's art that characterize his brutal vision of contemporary life:

 a.

 b.

 c.

20. What subject was David Wojarowicz exploring in the work shown on FIG. 36-48?

21. What artistic technique did Wodiczko utilize to draw attention to the plight of the homeless?

22. What medium does Magdalena Abakanowicz use for her expressive sculptures?

23. What is Jeff Koons exploring in works like *Pink Panther* (FIG. 36-51)?

24. To what was Arneson reacting in his self-portrait known as *California Artist* (FIG. 36-52):

In what way is the work a critize of the contemporary art world?

25. How does Tansey's *A Short History of Modernist Painting* (FIG. 36-53) illustrate the ambiguities and paradoxes of Postmodernist Pictorialism?

26. What is Hans Haake critiquing in *MetroMobiltan* (FIG. 36-54)?

ARCHITECTURE AND SITE-SPECIFIC ART

1. What form did Frank Lloyd Wright use as the basis for his design for the Guggenheim Museum (FIGS. 36-55)?

2. What forms provided the inspiration for Le Corbusier's Notre Dame du Haut (FIGS. 36-56 and 35-57)?

In what way does Notre Dame du Haut differ from Le Corbusier's earlier works like the Villa Savoy (FIG. 35-75)?

3. Who designed the TWA Terminal at Kennedy Airport in New York City (FIG. 36-58):

What design motif did he use throughout the structure?

4. List two architectural metaphors used in the Opera House in Sydney Australia (FIG. 36-59):

a.

b.

5. What architectural style is represented by the Seagram Building in New York (FIG. 36-60)?

6. What type of impression was the Sears Tower in Chicago (FIG. 36-61) intended to project?

What features of the building helped to create that impression?

7. Briefly describe the Vietnam Memorial in Washington D.C. (FIG. 36-62):

Who designed it?

Why do you think visitors respond to it so strongly?

8. List three terms often associated with Postmodern architecure:

a. b. c.

9. What historical styles are cited by Charles Moore in his Piazza d'Italia (FIG. 36-63)?

10. How did Phillip Johnson's style change in his AT&T Tower in New York (FIG. 36-64)?

11. What aspects of Graves' Portland Building (FIG. 36-65) can be considered Postmodernist?

12. How did Lionel Venturi's work and writing depart from the Modernist axiom "form follows function"?

13. What is the official name for the "Beaubourg"?

Where is it located?

What is significant about its structure?

14. List six adjectives that can describe Deconstructivist architecture:

a. b.

c. d.

e. f.

Name a building:

15. List three features of Ghery's Guggenheim Bilbao illustrates Deconstructivist principles:

a.

b.

c.

16. What did Liebeskind say was his inspiration for the Denver museum extension ?

17. Name a leading American Environmental artist:

Briefly describe his techniques.

18. For what type of art were Christo and his wife Jeane-Claude most famous?

19. Why did the GSA remove Serra's *Tilted Arc* from the plaza in front of the Federal Building in New York City?

What important issues were raised by this action?

PERFORMANCE AND CONCEPTUAL ART AND NEW MEDIA

1. Who was John Cage?

2. What are "Happenings"?

Who developed them?

3. What type of art did Fluxus artists create?

4. What sort of art was produced by Kazno Shirago and the Gutac group in Oasaka?

5. Who added a feminist aspect to Performance Art?

6. Briefly state the artistic philosophy of Joseph Beuys.

7. What inspired the work of Jean Tinguely and what sort of materials did he use?

8. What is meant by "Conceptual Art"?

9. What was Bruce Nauman's favorite material?

What was his favorite subject?

10. List six interests that video technology allowed Nam June Paik to combine:

a. b.

c. d.

e. f.

11. Name four artists who utilize computers and/or video in their work:

a. b.

c. d.

Which one uses digital video to encourage introspection and explore spirituality?

DISCUSSION QUESTIONS

1. What European political events and artistic movements influenced the development of American Abstract Expressionism? How?

2. Discuss the use of industrial processes in the work of David Smith, Julio Gonzalez, and Donald Judd. Which processes did each use and how were the processes related to the artist's esthetic concerns?

3. Compare Hamilton's *Just What Is It That Makes Today's Homes So Different, So Appealing?* (FIG. 36-20) with Campin's *Merode Altarpiece* (FIG. 20-4). Discuss the compositional structure and the symbolism of both works, along with their cultural meanings.

4. Can you relate Judd's *Untitled* (FIG. 36-16), Tinguely's *Homage to New York* (FIG. 36-78) , Francis Bacon's *Painting* (36-3), Nevelson's *Tropical Garden II* (FIG. 36-17), and Hannah Wilke's *Starification Object Series* (FIG. 36-38) to the earlier traditions of Classic and Romantic art? How?

5. Compare the self-portraits of Cindy Sherman (FIG. 36-35), Ana Medieta (FIG. 36-37), Adrian Piper (FIG. 36-82), Chuck Close (FIG. 36-28), and Robert Arneson (FIG. 36-52) with earlier self-portraits like those of Judith Leyster (FIG. 25-11), Vigee-Lebrun (FIG. 29-14) and Rembrandt (FIG. 25-15). Discuss the techniques used by each artist as well as the view of the self that each presents.

6. Compare Francis Bacon's *Painting* (FIG. 36-3) and David Wojnarowicz' "When I put my hands on your body" (FG. 36-48) with Traini's *Triumph of Death* (FIG. 19-20) and Fuseli's *The Nightmare* (FIG. 30-9). What attitudes toward society does each represent and how is each reflective of its time.

7. Select four of the following landscapes: Huang Gongwang, *Dwelling in the Fuchun Mountains* (FIG. 27-4), *Gardenscape* from the Villa of Liva (FIG. 10-20), Sesshu's *Broken-ink Landscape* (FIG. 28-3), Ruisdael's *View of Haarlem* (FIG. 25-18), Bierstadt's *Among the Sierra Nevada Mountains, California* (FIG. 30-25), Cezanne's *Mount Sainte-Victoire* (FIG. 31-20), Van Gogh's *Starry Night* (FIG. 31-17) Tansey's *A Short History of Modernist Painting* (FIGS. 36-53), Kiefer's *Nigrido* (FIG. 36-32) and Schnabel's *The Walk Home* (FIG. 36-31). Compare the formal techniques each artist used and discuss what each work implies about the society that produced it.

8. Discuss the changes in still life depiction from the time of the Romans through the modern day. Select from the *Still Life with Peaches* from Herculaneum (FIG. 10-26), Claes, *Vanitas Still Life* (FIG. 25-21), Cezanne, *The Basket of Apples* (FIG. 31-21), Picasso's *Still Life with Chair-caning* (FIG. 35-16), Warhol's *Green Coca-Cola Bottles* (FIG. 36-24), Flack's *Marilyn* (FIG. 36-27), and Hanson's *Supermarket Shopper* (FIG. 36-29). What was the purpose of each art work and what techniques did the artists use to achieve those purposes?

9. What changes in social and religious attitudes are represented by the comparison of *Christ in Majesty* from Moissac (FIG. 17-1), *Pieta* (FIG. 18-51), Puvis de Chavannes, *The Sacred Grove* (FIG. 31-22) , Rothko's *No. 13* (FIG. 36-9), Bill Viola's *The Crossing* (FIG. 36-83), Judy Chicago's *The Dinner Party* (FIG. 36-33), and Chris Ofili *The Holy Virgin Mary* (FIG. 36-44).

10. Recently, the International Style, which has dominated the architecture of the past fifty years, has fallen into disfavor. What criticisms have been leveled against it? In your opinion, are they justified? Describe some of the alternatives that have been tried.

11. One reason for the stylistic similarity of International Style buildings, whether erected in Brasilia, Tokyo, Paris, or New York, is the architects' dependence upon intricate machinery to control the interior climates of their buildings. Do you feel that increasing reliance on complex technology is still justified in view of dwindling energy sources and the threat of accompanying economic and social upheavals throughout the world? What practical alternatives, if any, do you see?

12. In what way do the work of twentieth-century African-American artists Jacob Lawrence (FIG. 35-64) Faith Ringold (Fig. 36-41) and Lorna Simpson (FIG. 36-42) differ from that of nineteenth-century African-American artists Henry Ossawa Tanner (FIG. 30 -40) and Edmonia Lewis (FIG. 30-41)? Discuss both the style and subject matter of each artist.

LOOKING CAREFULLY, ANALYZING AND RELATING

Look carefully at the representations of two late 20th century high tech buildings: Rogers and Piano's Pompidou Center (FIG. 36-67) and Gehry's Guggenheim Museum (FIG. 36-69 and 36-70) and write at least a page comparing them. Although they both emphasize the use of modern technology, the effects they create are quite different. How did the use of materials influence the visual effects each produced? Describe each building as fully as you can, and then relate the two buildings to earlier architectural traditions of Classical and Baroque. What earlier buildings might you relate them to? Explain the features that made you think of the relationship.

SUMMARY OF PAINTING & NEW MEDIA IN EUROPE & AMERICA
AFTER 1945

Fill in as much of the chart as you can from memory. Check your answers against the text and complete the chart. Include additional material supplied by your instructor.

	Typical Examples	Stylistic Characteristics	Significant Historical Events, Ideas, etc.
Bacon Style: Country:			
Dubuffet Style: Country:			
Pollock Style: Country:			
De Kooning Style: Country:			
Rothko Style: Country:			
Neuman Style: Country:			
Kelly Style: Country:			
Stella Style: Country:			
Frankenthaler Style: Country:			
Louis Style: Country:			

SUMMARY OF PAINTING & NEW MEDIA IN EUROPE & AMERICA
AFTER 1945 (continued)

	Typical Examples	Stylistic Characteristics	Significant Historical Events, Ideas, etc.
Hamilton Style: Country:			
Johns Style: Country:			
Rauchenberg Style: Country:			
Lichtenstein Style: Country:			
Warhol Style: Country:			
Flack Style: Country:			
Close Style: Country:			
Schnabel Style: Country:			
Keifer Style: Country:			
Chicago Style: Country:			

SUMMARY OF PAINTING & NEW MEDIA IN EUROPE & AMERICA
AFTER 1945 (continued)

	Typical Examples	Stylistic Characteristics	Significant Historical Events, Ideas, etc.
Quick-to-See Smith Style: Country:			
Golub Style: Country:			
Wojnarowicz Style: Country:			
Wodiczko Style: Country:			
Tansey Style: Country:			
Hacke Style: Country:			
Paik Style: Country:			
Piper Style: Country:			
David Em Style: Country:			
Viola Style: Country:			
Holzer Style: Country:			
Oursler Style: Country:			

SUMMARY OF SCULPTURE & PERFORMANCE IN EUROPE & AMERICA AFTER 1945

Fill in as much of the chart as you can from memory. Check your answers against the text and complete the chart. Include additional material supplied by your instructor.

	Typical Examples	Stylistic Characteristics	Significant Historical Events, Ideas, etc.
Giacometti Style: Country:			
David Smith Style: Country:			
Tony Smith Style: Country:			
Judd Style: Country:			
Nevelson Style: Country:			
Bourgeois Style: Country:			
Hesse Style: Country:			
Oldenburg Style: Country:			
Hansen Style: Country:			
Kiki Smith Style: Country:			

SUMMARY OF SCULPTURE & PERFORMANCE IN EUROPE & AMERICA
AFTER 1945 (continued)

	Typical Examples	Stylistic Characteristics	Significant Historical Events, Ideas, etc.
Edwards Style: Country:			
Hammons Style: Country:			
Abakonowicz Style: Country:			
Koons Style: Country:			
Arneson Style: Country:			
Fluxus Style: Country:			
Shiraga Style: Country:			
Schneeman Style: Country:			
Beuyes Style: Country:			
Tinguely Style: Country:			
Kosuth Style: Country:			
Nauman Style: Country:			

SUMMARY OF ARCHITECTURE & INSTALLATIONS IN EUROPE & AMERICA AFTER 1945

Fill in as much of the chart as you can from memory. Check your answers against the text and complete the chart. Include additional material supplied by your instructor.

	Typical Examples	Stylistic Characteristics	Significant Historical Events, Ideas, etc.
Wright Style: Country:			
Le Corbusier Style: Country:			
Saarinen Style: Country:			
Utzon Style: Country:			
Mies van der Rohe Style: Country:			
Skidmore, Owings & Merril Style: Country:			
Maya Lin Style: Country:			
Johnson Style: Country:			
Moore Style: Country:			

SUMMARY OF ARCHITECTURE & INSTALLATIONS IN EUROPE & AMERICA AFTER 1945 (continued)

	Typical Examples	Stylistic Characteristics	Significant Historical Events, Ideas, etc.
Graves Style: Country:			
Rogers & Piano Style: Country:			
Venturi Style: Country:			
Behmisch Style: Country:			
Gehry Style: Country:			
Liebeskind Style: Country:			
Smithson Style: Country:			
Christo & Jean-Claude Style: Country:			
Serra Style: Country:			

PREPARING FOR YOUR EXAMINATIONS

As you prepare to take your examination you should review the notes you took on your lectures as well as the work you did in your Study Guide. (Look back at the **Introduction to the Study Guide** for tips on taking notes and creating your own charts, as well as detailed instructions on studying for and taking examinations.) If you have not yet filled out the Summary charts in the Guide, this is the time to do it, integrating materials from your lecture notes with materials in the Guide itself. This activity is the most useful thing that you can do.

The self-quiz included below, as well as the materials included in the **Companion Site** for the textbook, can be a great help in preparing you for course examinations. The questions are modeled on those commonly asked on art history examinations: multiple choice, short answer questions, chronology exercises, essay questions and attribution of unknown images.-Take the self-quiz and check your answers in the back of the book; see how well you grasp the material. If you are unclear about certain areas review the text and utilize the on-line Web Site and WebTutor tools to fill in the gaps. You may also wish to consult the WorldImages website which contains many art historical images and is the source of the images used in the quiz below. See http://worldimages.sjsu.edu. Note particularly the Art History survey section.

Self-Quiz
RENAISSANCE AND BAROQUE

CHAPTERS 19-25

MULTIPLE CHOICE
Circle the most appropriate answer.

1. Which of the following architects best exemplifies the principles of High Renaissance style?

 a. Michelozzo b. Bramante c. Brunelleschi d. Borromini

2. Which of the following Dutch artists specialized in landscape?

 a. Hals b. Vermeer c. van Ruisdael d. Kalf

3. A *fête galante* would most likely have been painted by:

 a. Poussin b. Watteau c. Rubens d. Velazquez

4. The combination of Germanic and Italian characteristics is most apparent in the work of:

 a. Leonardo b. Grünewald c. Bosch d. Holbein

5. The counter-positioning of a figure about its central axis with the weight of the body on one leg and the other leg relaxed is called:

 a. chiaroscuro b. contrapposto c. condottiere d. sfumato

6. Tenebroso refers to:

 a. A small range of tone between light and dark
 b. Objects in a painting that have been painted over
 c. The point where orthogonals converge
 d. A technique using violent contrasts of light and dark

7. A painting using much gold, flat patterns, a high horizon life, elegant figure style, many details from nature and curvilinear line would most likely be:

 a. High Renaissance b. Early Renaissance c. Mannerism d. International Gothic

8. The paintings of Vermeer most often convey a feeling of:

 a. agitation b. ostentation c. serenity d. pomposity

9. Which of the following artists best exemplifies French Classical Baroque style?

 a. Boucher b. Poussin c. Le Nain d. Rubens

10. In which of the following cities did Borromini build the majority of his buildings?

 a. Rome b. Florence c. Milan d. Venice

11. The supreme master of the group portrait was:

 a. Hals b. Steen c. Gainsborough d. Anguissola

12. Seventeenth-century Dutch paintings were characteristically:

 a. commissioned by the aristocracy b. commissioned by the church
 c. scarce and hard to find d. sold on the open market

13. Which of the following is LEAST characteristic of Baroque art?

 a. dramatic use of light b. energy and complexity of design
 c. calm, classical figures d. a reflection of the Counter-Reformation

14. Which is LEAST characteristic of Baroque architecture?

 a. preference for oval over circular plans
 b. preference for centralized rectangular and circular motifs
 c. emphasis on a grand central entrance
 d. greater variation in the depth of wall surface

15. The *School of Athens* in the Vatican was painted by:

 a. Leonardo b. Raphael c. Michelangelo d. Bramante

16. Which building is located in Paris?

 a. Palazzo Vecchio b. Campidoglio c. Louvre d. Chambord

17. Oil painting was first used by the:

 a. fifteenth-century Flemish (Netherlanders) b. fifteenth-century Florentines
 c. sixteenth-century Venetians d. fifteenth-century Germans

18. The *Virgin on the Rocks* illustrates both the scientific and artistic interests of:

 a. Botticelli b. Leonardo c. Raphael d. Durer

19. The innovative frescos of the Arena chapel were painted by:

 a. Masaccio b. Michelangelo c. Giotto d. Duccio

20. Which artist was commissioned to design a tomb for Julius II?

 a. Dontaello b. Bernini c. Michelangelo d. Giovanni da Bologna

21. A concern for realism, psychological portraiture, and emotional expression would most likely be found in works of:

 a. Mannerism b. International Gothic
 c. Italian High Renaissance d. German Renaissance

22. Which of the following LEAST characterizes the International Gothic style:
 a. intricate ornamentation b. rational perspective
 c. splendid processions d. brilliant color and costuming

23. An important characteristic of much fifteenth-centuryFlemish (Netherlandish) art was the use of:

 a. linear pespective b. disguised symbolism
 c. painterly brush strokes d. sfumato

24. The use of sfumato, full figures, psychological interpretation, and anatomical accuracy most correctly describes the work of:

 a. Lorenzetti b. El Greco c. Leonardo d. Botticelli

25. Which of the following is NOT characteristic of High Renaissance figure painting?

 a. slow, rhythmic movement b. elongaton and distortion
 c. restrained gravity d. balance and order

26. Which artist created paintings illustrating the life of peasants?

 a. Le Nain b. Holbein c. Brueghel d. both a and c

27. The Limbourg brothers were known for their:

 a. frescoes b. panel painting c. engravings d. manuscript illuminations

28. Bout's work is best classified as:

 a. Italian High Rensaissance b.Fifteenth-century Flemish (Netherlandish)
 c. International Gothic d. Mannerist

29. Which of the following Baroque painters did NOT do frescoed ceilings?

 a. Pozzo b. Pietro da Cortona
 c. Caravaggio d. Annibale Carracci

30. Which of the following architects did NOT take part in the building of Saint Peter's or its piazza?

 a. Bramante b. Michelangelo c. Borromini d. Bernini

CHRONOLOGY EXERCISE
Write down the letter corresponding to the appropriate <u>Century</u> beside the name of the artist or art work:

____31. Palladio a. 14th Century

____32. Bunelleschi b. 15th Century

____33. van der Weyden c. 16th Century

____34. Velazquez d. 17th Century

____35. Bernini

____36. Masaccio

____37. Holbein

____38. Van Ruisdael

____39. Bruegel

____40. Bramante

STYLISTIC EXERCISE

Write down the letter corresponding to the appropriate Style beside the name of the artist:

_____41. Borromini

_____42. Donatello

_____43. Raphael

_____44. Dürer

_____45. Velazquez

_____46. Memling

_____47. Uccello

_____48. Parmigianino

_____49. Hals

_____50. Rembrandt

a. Northern Renaissance

b. Italian 15th c Renaissance

c. Italian High Renaissance

d. Mannerist

e. Baroque

GEOGRAPHIC EXERCISE

Indicate the Architect or Artist and the Country where each of the works is found.

Building	Architect / Artist	Country
51. Sistine Ceiling	_____	_____
52. Las Meninas	_____	_____
53. Ghent Altarpiece	_____	_____
54. Dome of Florence Cathedral	_____	_____
55. Banqueting Hall, Whitehall	_____	_____
56. San Carlo alle Quattro Fontane	_____	_____
57. Isenheim Altarpiece	_____	_____

58. Ecstasy of St. Theresa _____ _____

59. Mona Lisa _____ _____

60. Pazzi Chapel, Florence _____ _____

SHORT ANSWER QUESTIONS
Answer the question or finish the sentence.

61. What is meant by the term "Maniera graeca"?

62. Where did el Greco do most of his work?

 What type of subject matter did he prefer?

63. What is portrayed in Ambrozio Lorenzetti's frescos in Siena, and why are they important?

64. Name three fifteenth-century artists who were very much interested in linear perspective:

65. What features characterize the work of Domenico Ghirlandaio?

66. Who were the greatest patrons of art in fifteenth-century Florence?

67. Describe the difference between aerial and linear perspective:

68. Name one French Renaissance portrait painter and characterize his style:

69. How was the work of Cranach associated with the Protestant Reformation?

70. How does Van der Weyden's style differ from that of Van Eyck?

71. In what type of art did Hans Holbein specialize?

 In what country did he do his best know works?

72. Name four architects who worked on Saint Peter's Rome:

73. In what type of painting did Van Ruisdale specialize?

74. Who was Velazquez' major patron? In what country?

75. Briefly describe the characteristics of Caravaggio's style:

76. What is the "Grand Manner"?

77. Name at least one building that demonstrates the principles of the French classical Baroque style:

78. Name the Baroque artist that is famous for both his sculpture and his architecture. In what city did he do most of his work?

79. What type of subject matter was portrayed in a "veduta" painting?

80. Name two English architects who worked in the 17th or 18th centuries:

IMAGE MULTIPLE CHOICE

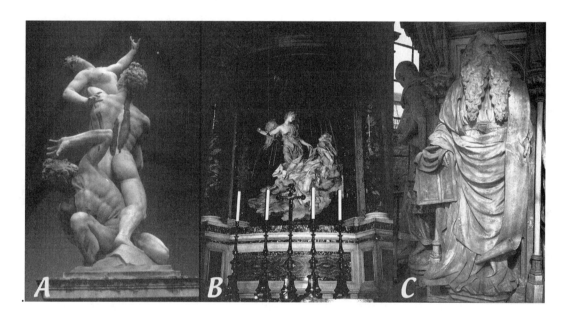

81. The sculptor who created image A above was:

 a. Donatello b. Giovanni da Bologne c. Michelangelo d. Goessart

82. The style of image A above can best be considered as:

 a. Early Renaissance b. High Renaissancec. Mannerist d. Baroque

83. The sculptor who created image B above was:

 a. Bernini b. Borromini c. Michelangelo d. Verrochio

84. The subject of image B above is:

 a. Annunciation b. Ecstasy of St. Theresa
 c. Death of St. Agatha d. Mary Magdalene in Ecstasy

85. The style of image B above is a good example of:

 a. Baroque b. High Renaissancec. Mannerist d. Late Gothic

86. Image C above:

 a. depicts the Well of Moses b. comes from near Dijon in France
 c. was made by Claus Sluter d. all of the above

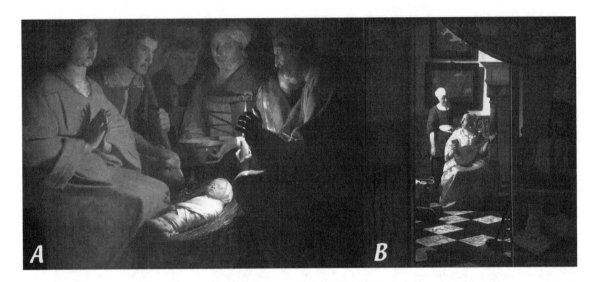

87. The artist who created image A above was:

 a. Hals b. Vermeer c. De la Tour d. Caravaggio

88. The artist who created image B above was:

 a. Van Eyck b. Vermeer c. Van Dyck d. Jan Steen

89. The nationality of the artist who created image B above was:

 a. French b. German c. Dutch d. Italian

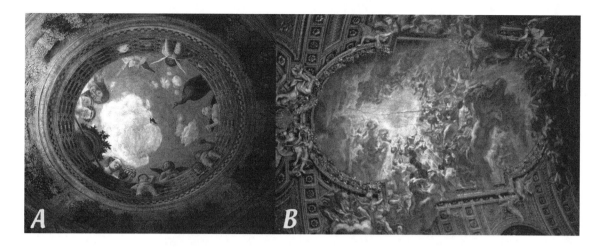

90. The artist who created image A above was:

 a.Van Eyck b. Mantegna c. Della Francesca d. Van der Weyden

91. The patron and site for image A above was:

 a. Pope Julius II, Rome b. Louis XIV, Versailles
 c. Cardinal Rolin, Beaune d. Duke Ludovico Gonzaga, Mantua

92. The work shown in image B above was commissioned by the:

 a. Franciscans to decorate their church in Florence
 b. Dominicans to show the significance of the Inquisition
 c. Jesuits to illustrate Counter-Reformation beliefs
 d. King Francis I to decorate his palace at Chambord

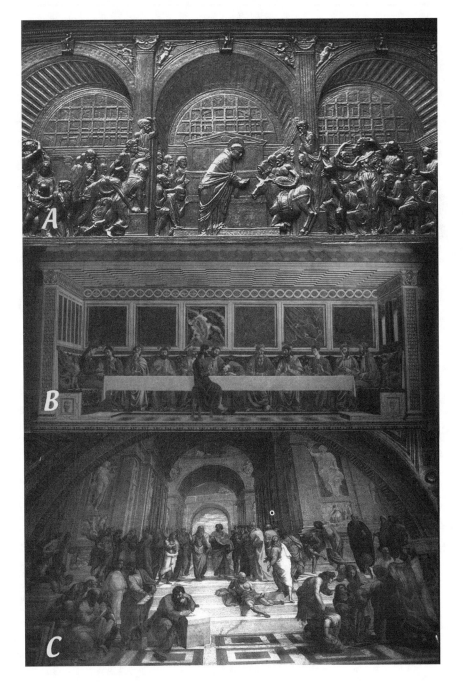

93. The creator of image A above was:

 a. Donatello b. Mantegna c. Brunelleschi d. Durer

94. Image A illustrates the principle of:

 a. sfumato b. chariscuro c. single point perspective d. both a and c

95. The creator of image B above was:

 a. Donatello b. Castagno c. Leonardo d. Mantegna

96. The person sitting on the near side of the table in image B above represents

 a. Christ b. John the Baptist c. Judas d. St. Paul

97. The subject of image C above depicts

 a. Members of the French Academy in Rome b. The School of Athens
 c. Old Testament prophets d. Members of the Council of Trent

98. The creator of image C above was:

 a. Donatello b. Raphael c. Rubens d. Poussin

99. The fresco shown in image C above was painted in:

 a. Florence b. Rome c. Paris d. Madrid

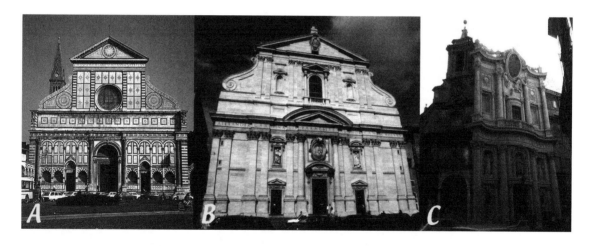

100. The architect who designed the church in image A was:

 a. Bramante b. Alberti c. Borromini d. Wren

101. The architect who designed the church in image B was:

 a. Maderno b. Bramante c. Palladio d. Brunelleschi

102. The architect who designed the church in image c was:

a. Brunelleschi b. Palladio c. Michelozzo d. Borromini

103. Which of the above churches was (were) built in Rome?

a. Image A b. Images A and B c. Images A and C d. Images B and C

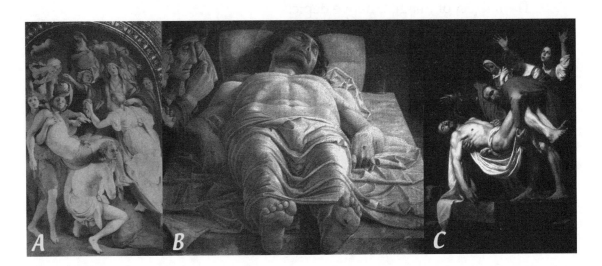

104. The creator of image A above was:

a. Pontormo b. Mantegna c. Cellini d. Durer

105. The creator of image B above was:

a. Donatello b. Mantegna c. Durer d. Caravaggio

106. The creator of image C above was:

a. Leonardo b. Mantegna c. Ribera d. Caravaggio

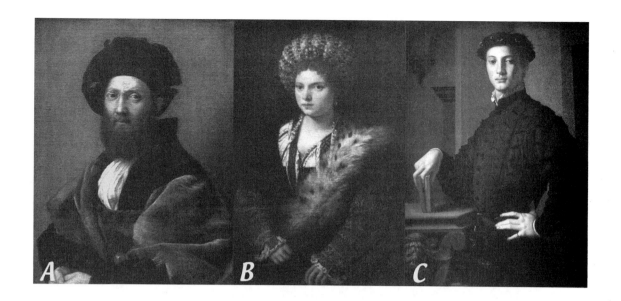

107. The artist who painted the portrait shown in image A above was:

 a. Leonardo b. Raphael c. Rubens d. Tintoretto

108. The artist who painted the portrait shown in image B above was:

 a. Titian b. Raphael c. Leonardo d. Veronese

109. The sitter for the portrait shown in image B above was:

 a. Mona Lisa b. Isabella d'Este c. Lucrezia Borgia d. St. Theresa

110. The artist who painted the portrait shown in image C above was:

 a. Leonardo b. Raphael c. Bronzino d. Veronese

IMAGE-BASED FILL IN

Write the words that best complete the sentence or answer the question.

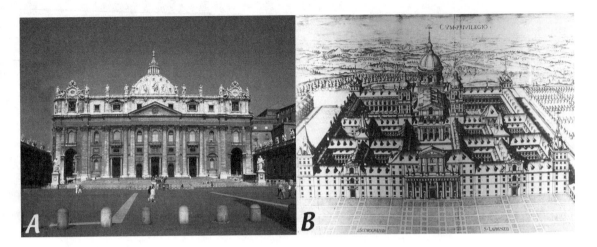

111. What is the name of the building shown in figure A above?

112. Where is the building shown in figure A above located?

113. Name three architects that worked on is the building shown in figure A above:

114. What is the name of the building shown in figure B above?

115. Where is the building shown in figure B above located?

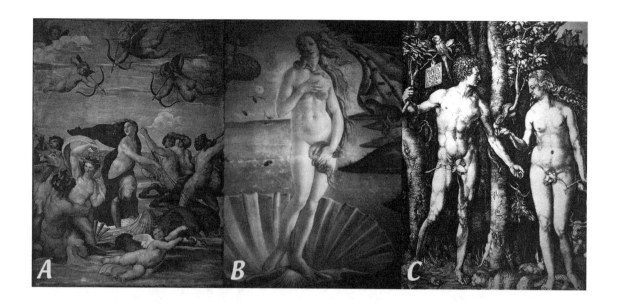

116. The artist who painted the image shown in figure A above was:

117. What is the subject of the image shown in figure A above?

118. The artist who painted the image shown in figure B above was:

119. What is the subject of the image shown in figure B above?

120. The artist who painted the image shown in figure C above was:

121. What is the subject of the image shown in figure C above?

122. What medium was used to create figure C above?

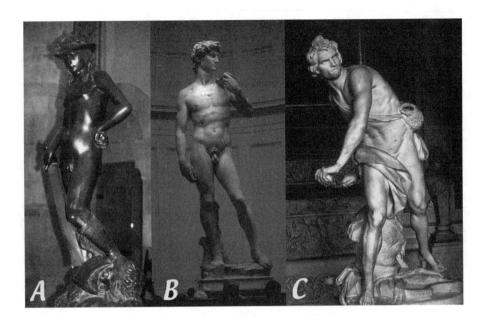

123. What is the subject of the three sculptures shown above?

124. The artist who created the sculpture shown in figure A above was:

125. The artist who created the sculpture shown in figure B above was:

126. The artist who created the sculpture shown in figure C above was:

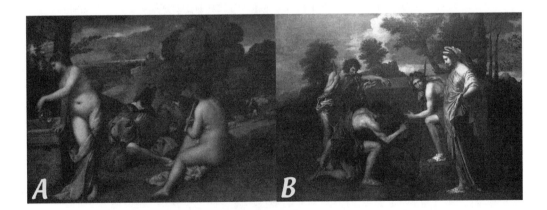

127. The artist who painted the image shown in figure A above was:

128. In what century was the image shown in figure A painted?

129. The artist who painted the image shown in figure B above was:

130. In what century was the image shown in figure B painted?

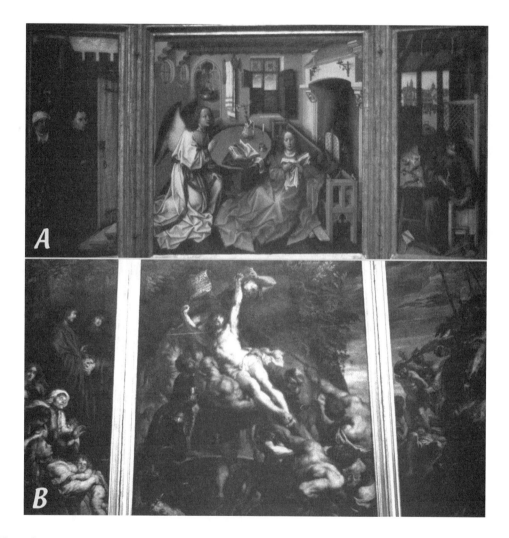

131. What format was used for the two images shown above?

132. The artist who painted the image shown in figure A above was:

133. In what century was the image shown in figure A painted?

134. What is the subject of the image shown in figure A above?

135. The artist who painted the image shown in figure B above was:

136. In what century was the image shown in figure B painted?

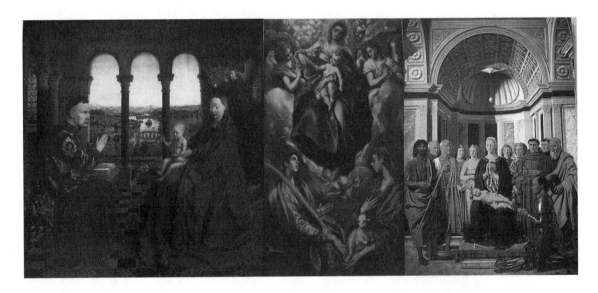

137. The artist who painted the image shown in figure A above was:

138. In what country was the image shown in figure A painted?

139. The artist who painted the image shown in figure B above was:

140. In what country was the image shown in figure B painted?

141. The artist who painted the image shown in figure C above was:

142. In what country was the image shown in figure C painted?

143. The artist who painted the image shown in figure A above was:

144. In what century was the image shown in figure A painted?

145. The artist who painted the image shown in figure B above was:

146. In what century was the image shown in figure B painted?

IDENTIFICATION ESSAYS

147. Compare the two images of the Virgin shown below, attributing each to an artist, country, century and style. Give the reasons for your attribution.

A. Artist:

 Country:

 Century:

 Style:

 Reasons:

B. Artist:

 Country:

 Century:

 Style:

 Reasons:

148. Study the photograph and the plan of the building below, attributing it to a country, century and style. Give the reasons for your attribution.

Country:

Century:

Style:

Reasons:

149. Compare the two paintings shown below, attributing each to an artist, country, century and style. Discuss how these two paintings illustrate the different approaches to the use of light that characterizes the work of these two artists.

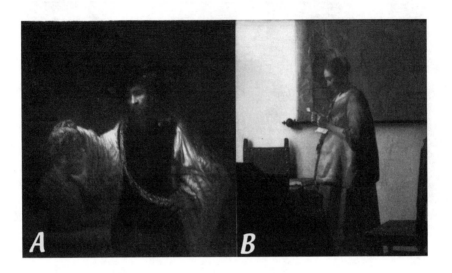

A. Artist:

Country:

Century:

Style:

Reasons:

B. Artist:

Country:

Century:

Style:

Reasons:

150. Compare the two sculptures shown below, attributing each to an artist, country, century and style. Give the reasons for your attribution.

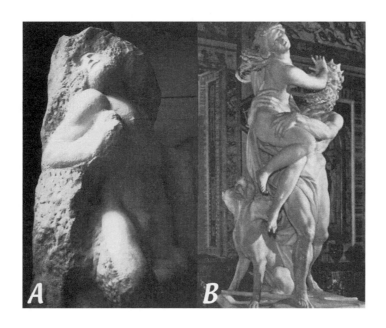

A. Artist:

 Country:

 Century:

 Style:

 Reasons:

B. Artist:

 Country:

 Century:

 Style:

 Reasons:

ESSAYS
Select one essay and be sure and cite specific examples to illustrate your argument.

1. Compare the development of painting during the 15th century in Florence and the Netherlands. What were the major concerns and achievements of the two areas. Select two artists from each area to illustrate your argument, citing specific works.

2. Discuss patronage during the 17th century in Europe. Note the different types of patrons that were found in Italy, Holland, Belgium, France and Spain and the effects they had on the art that was produced in those countries.

3. Discuss the development of architecture in Italy from the 15th through the 17th centuries . select one architect from each century that you think best exemplifies the architecture of the Early Renaissance, the High Renaissance, Mannerist, and the Baroque period, and discuss how the styles of each period are embodied in a specific building they created.

QUIZ ANSWERS
RENAISSANCE AND BAROQUE

MULTIPLE CHOICE; CHRONOLOGY AND STYLE

1. b	11. a	21. d	31. c	41. e
2. c	12. d	22. b	32. b	42. b
3. b	13. c	23. b	33. b	43. c
4. d	14. b	24. c	34. d	44. a
5. b	15. b	25. b	35. d	45. e
6. d	16. c	26. d	36. b	46. a
7. d	17. a	27. d	37. c	47. b
8. c	18. b	28. b	38. d	48. d
9. b	19. c	29. c	39. c	49. e
10. a	20. c	30. c	40. c	50. e

GEOGRAPHIC EXERCISE

51. Michelangelo, Italy

52. Velasquez, Spain

53. Jan Van Eyck, Flanders (Netherlands)

54. Brunellesci, Italy

55. Inigo Jones , England (Great Britain)

56. Borromini, Italy

57. Grunewald, Germany

58. Bernini, Italy

59. Michelangelo, Italy

60. Brunelleschi, Italy

.

SHORT ANSWERS

61. The "Maniera Greca," also known as the Italo-byzantine style, is characterized by a gold background, flattened figures, and shallow "stage-set" space.

62. El Greco worked primarily in Spain, and the majority of his pictures had religious subject matter.

63. In Good government the Lorenzetti showed the peaceful life in the city and country, as well as allegorical figures. In addition they did scenes illustrating Bad Government. Everyday scenes from the county and city were innovative.

64. Three from the following: Masaccio, Brunelleschi, Castagno, Uccello, Ghiberti, Piero della Francesca, and Mantegna.

65. Ghirlandaio was a synthesizer, not an innovator. His work presents an excellent picture of Florence at the end of the fifteenth century, giving detailed representations of the life, pageantry, costume and material wealth of the citizens.

66. The Medici.

67. Artists using aerial perspective lessen the intensity of colors and blur the edges of forms to indicate distance. They often use blue tones that recede to indicate far distance. Linear perspective is a mathematically based system that creates a window into space, and in which all parallel lines that are perpendicular to the picture plane converge at a single point known as the vanishing point, which falls on the horizon.

68. Jean Clouet created elegant, sharply delineated figures in a Mannerist style which stressed the flatness of the picture plane.

69. Cranach was a friend of Martin Luther who was responsible for starting the Protest Reformation in Germany. Cranch created woodcuts praising the protestant cause and criticizing the papacy.

70. Van der Weyden stressed human action and emotion rather than the complex symbolism seen in Van Eyck's work.

71. Portraiture, much of which was done in England.

72. Four out of five: Bramante, Michelangelo, della Porta, Maderno, Bernini.

73. Still life

74. Phillip IV of Spain

75. Dynamic composition, use of tenebroso or "night lighting" that utilized strong contrasts of light and dark and realistic detail.

76. Artists working in the Grand Manner selected grand heroic or religious subjects, not low life subjects of genre scenes, and their works were painted broadly, without attention to minute details.

77. Any of the following: East façade of the Louvre, or the Versailles Palace.

78. Bernini. Rome

79. Characteristic scenes of a city, best exemplified in the work of Canaletto.

80. Inigo Jones and Sir Christopher Wren.

IMAGE-BASED MULTIPLE CHOICE

81. b	87. c	93. a	99. b	105. b
82. c	88. b	94. c	100. b	106. d
83. a	89. c	95. b	101. a	107. a
84. b	90. b	96. c	102. d	108. a
85. a	91. d	97. b	103. d	109. b
86. d	92. c	98. b	104. a	110. c

IMAGE-BASED FILL IN

111. St. Peter's basilica.

112. Vatican or Rome.

113. Three out of Bramante, Michelangelo, Della Porta, Maderno, Bernini

114. El Escorial.

115. Outside Madrid in Spain.

116. Raphael.

117. Galatea.

118. Botticelli.

119. Birth of Venus.

120. Durer.
121. Adam and Eve or Fall of Man.

122. Engraving.

123. David (and Goliath).

124. Donatello

125. Michelangelo

126. Bernini

127. Giorgioni

128. 16th

129. Poussin

130. 17th c

131. Triptych

132. Campin (or Master of Flemalle)

133. 15th c

134. Annunciation

135. Rubens

136. 17th c

137. Van Eyck

138. Netherlands (or Holland or Belgium)

139. El Greco

140. Spain

141. Piero della Francesca

142. Italy

143. Bruegel

144. 16th c

145. van Ruisdale

146. 17th c

IDENTIFICATION ESSAYS

147. A. Jan van Eyck, Flanders, fifteenth century, Northern Renaissance (*The Annunciation*, c. 1435. National Gallery, Washington, D.C.)

B. Raphael, Italy, sixteenth century, High Renaissance (*Madonna in the Meadow*, 1505. Kunsthistorisches Museum, Vienna).

The precision and clarity of the rendition of every form in this Annunciation scene indicate its fifteenth-century northern origin. The emphasis on the specific, as shown in the rich brocaded robe and the sparkling jewels, point to van Eyck as the artist. Similar details are shown in the *Ghent Altarpiece*. For example, the slightly awkward position of the Virgin of this panel is very similar to that of the Virgin on the exterior of his *Ghent Altarpiece*. The slight upward tilt of the floor indicates that single-point linear perspective was not used to construct the architectural setting, as most likely would have been done by an Italian painter of the same period. Rich surface, precise details, and symbolism are more important than unified space. As in other fifteenth-century Netherlandish works, disguised symbolism plays an important role in this painting, with such things as the scenes depicted on the capitals of the columns and the tiles of the floor adding to the devotional meaning of the altarpiece.

Madonna in the Meadow (The Madonna with the Christ Child and St. John) is an excellent example of Raphael's High Renaissance style, for it demonstrates the tightly organized pyramidal composition that was favored by High Renaissance artists, as well as the subtle chiaroscuro Raphael used to model the idealized faces. This work demonstrates Raphael's striving to combine grace, dignity, and idealism with simplicity and logic. The beauty and calm dignity of these figures and their monumental form illustrate Raphael's great achievement in merging Christian devotion with pagan beauty.

148. Seventeenth century, Italy, Baroque (Bernini, Sant'Andrea al Quirinale, Rome, 1658-1670.)

The building illustrated here very clearly demonstrates the approach to form favored by Baroque architects. Variations of the oval were much more popular with Baroque architects than variations of the square and circle, which were the ideal forms for Renaissance architects. That preference is apparent in the plan of the Baroque church shown here. The façade also demonstrates the distinctive approach of Baroque architects. While the typical Renaissance façade is composed of discrete geometric units, carefully proportioned and coordinated, the façade of Sant'Andrea is composed of forms molded deeply in space, with curve playing against curve, creating a rich plastic surface. Many of the stylistic characteristics of this church, which was designed by Bernini, are apparent in other Baroque buildings as well, for example Borromini's church of San Carlo alle Quattro Fontane, the piazza of Saint Peter's, which was also designed by Bernini. All share with this building the Baroque delight in dynamic forms that reach out and embrace space, plastic handling of surfaces, contrast of concave and convex forms, and preference for oval plans rather than the more static forms of circle and square.

149. A. Rembrandt, Holland, seventeenth century (Aristotle with the Bust of Homer, 1653. Metropolitan Museum of Art, New York.)

B. Vermeer, Holland, seventeenth century (Young Woman Reading a Letter, c. 1662-1663. Rijksmuseum Stadhouderskade. Amsterdam.)

Rembrandt and Vermeer shared with other seventeenth-century Dutch artists an intense interest in the optics of light. However, their handling of it was quite different. Vermeer was primarily concerned with the creation of pictorial illusion and with extremely subtle optical effects. His attention to the effects of a warm and sunny light entering a quiet room, its reflections on the glass and the varying textures it illuminates are very clearly seen in this painting.

Rembrandt, on the other hand, used subtle modulations of light and dark to indicate spiritual or psychic states, to explore nuances of character and mood. The man represented here shares with many of the others portrayed by Rembrandt a sense of inwardness, of quiet contemplation. Only a portion of his face emerges out of the darkness, while the bust, on which he rests his hand, seems to glow with light. Rembrandt makes us wonder about the relationship between the man and the bust, even if we do not know that they represent Aristotle, the famous philosopher, contemplating a bust of the blind poet Homer. Is he recognizing the superiority of Homer's intuitive wisdom over his own more worldly knowledge and success, symbolized by the golden chain? (Even if you didn't write anything about the subject Rembrandt was representing, I hope that you wrote something about the mysterious effects he created.)

150. A. Michelangelo. Italy, Sixteenth century, High Renaissance (Awakening Slave. , 1520-1523, Accademia Florence.)

B. Bernini, Italy, seventeenth century, Baroque (*Rape of Proserpine*, 1621-1622. Borghese Gallery Rome.)

The work on the left was a figure that Michelangelo had started for the Tomb of Julius II but never finished. The figure shows the powerful musculature typical of Michelangelo and also illustrates his belief that a figure is entrapped in the stone and it is the sculptor's task to release. This figure struggles to be free from the marble just as the soul struggles to free itself from the body that keeps it from God.

The work on the right is typical of the dynamic Baroque sculptural style of Bernini. One must walk around the group in order to fully appreciate the complex composition, a characteristic of much Baroque sculpture. As he did in his rendition of *David*, Bernini captures the split-second action of the most dramatic moment. The two struggling bodies pull against each other with great energy, and Bernini contrasts the strong musculature of the male figure with the softer quality of female flesh. Virtuoso treatment of surface textures, combined with great energy and movement, is typical of Bernini, as is the work's expansive quality as it reaches out into space and refuses to be confined to the block from which it is carved.

ESSAYS:
Answers found throughout the text.

PREPARING FOR YOUR EXAMINATIONS

As you prepare to take your examination you should review the notes you took on your lectures as well as the work you did in your Study Guide. (Look back at the **Introduction to the Study Guide** for tips on taking notes and creating your own charts, as well as detailed instructions on studying for and taking examinations.) If you have not yet filled out the Summary charts in the Guide, this is the time to do it, integrating materials from your lecture notes with materials in the Guide itself. This activity is the most useful thing that you can do.

The self-quiz included below, as well as the materials included in the **Companion Site** for the textbook, can be a great help in preparing you for course examinations. The questions are modeled on those commonly asked on art history examinations: multiple choice, short answer questions, chronology exercises, essay questions and attribution of unknown images.-Take the self-quiz and check your answers in the back of the book; see how well you grasp the material. If you are unclear about certain areas review the text and utilize the on-line Web Site and WebTutor tools to fill in the gaps. You may also wish to consult the WorldImages website which contains many art historical images and is the source of the images used in the quiz below. See http://worldimages.sjsu.edu. Note particularly the Art History survey section.

Self-Quiz
THE MODERN WORLD

CHAPTERS 11, 12, 13, 14

MULTIPLE CHOICE
Circle the most appropriate answer.

1. Rococo artists most valued:

 a. disproportion and disturbed balance
 b. magnificence and order
 c. pyramidal compositions and chiaroscuro
 d. pleasure and delicacy
 e. symmetry and balance

2. The most important Realist painter of the mid-19th-century was:

 a. Degas
 b. Ingres
 c. Courbet
 d. Delacroix
 e. Géricault

3. The first Impressionist exhibition was held in the year:

 a. 1825
 b. 1854
 c. 1873
 d. 1890
 e. 1910

4. The short-lived student at David's studio who soon broke with David's use of style was:
 a. Delacroix
 b. Courbet
 c. Ingres
 d. Manet
 e. Géricault

5. In 1863 the French public was scandalized by a nude woman painted by:

 a. Ingres
 b. Goya
 c. Daumier
 d. Manet
 e. Renoir

6. The architect who created the Paris Opéra in the Neo-Baroque style was:

 a. Graves
 b. Ghery
 c. Garnier
 d. Wright
 e. Kahn

7. The photographer who introduced avant-garde art to the American public at his 291 Gallery in New York was:

 a. Fox-Talbot
 b. Close
 c. Stieglitz
 d. Daguerre
 e. Sherman

8. The artist who developed "combine paintings" was:

 a. Warhol
 b. Rauschenberg
 c. Kelly
 d. Hamilton
 e. Kruger

9. Movement is an important element in much of the art of:

 a. Calder
 b. Smith
 c. Breton
 d. Arneson
 e. Smithson

10. An architect who worked primarily in the Postmodern style was:

 a. Garnier
 b. Gaudi
 c. Graves
 d. Sullivan
 e. Wright

11. *The Sleep of Reason Produces Monsters* was created by:

 a. Ingres
 b. Goya
 c. Gros
 d. Kollwitz
 e. Goya

12. An important sculptor who worked primarily in the Neoclassical style was:

 a. Rodin
 b. Saint-Gaudens
 c. Canova
 d. Barye
 e. Lehmbruck

13. The sculptor whose work was most closely associated with Futurism was:

 a. Boccioni
 b. Rodin
 c. Tinguely
 d. Giacommeti
 e. Moore

14. The architect most closely associated with the Bauhaus was:

 a. Wright
 b. Gaudi
 c. van Alen
 d. Mies van der Rohe
 e. Gropius

15. Strong Expressionist tendencies are seen in the work of:

 a. Mondrian
 b. Munch
 c. Seurat
 d. Cézanne
 e. Matisse

16. The artist who believed that "the art of painting can consist only in the representation of objects visible and tangible to the painter" was:

 a. Ingres
 b. Delacroix
 c. Goya
 d. Courbet
 e. Dalí

17. The concern with images deriving directly from the subconscious is most
 apparent in the work of the:

 a. Expressionists
 b. Impressionists
 c. Cubists
 d. Surrealists
 e. Post-painterly Abstractionists

18. The mural entitled *Guernica* was painted by:

 a. Braque
 b. Picasso
 c. Kollwitz
 d. Kandinsky
 e. Beckmann

19. The first exhibition of the Fauves took place in:

 a. 1850
 b. 1874
 c. 1905
 d. 1930
 e. 1948

20. The hit of the Armory show, *Nude Descending a Staircase,* was painted by:

 a. Rauschenberg
 b. Ernst
 c. Duchamp
 d. Kandinsky
 e. Arp

21. Line is stressed over color in the works of:

 a. Ingres
 b. Delacroix
 c. Turner
 d. Monet
 e. Pissarro

22. Color is one of the most important factors in the work of:

a. Braque
b. Corbusier
c. Hannah Höch
d. Boccioni
e. Matisse

23. Which artist uses a formal approach to painting that is closest to that of Mondrian?

a. Friedrich
b. Rubens
c. Vermeer
d. Delacroix
e. Turner

24. Which of the following artists has the least Romantic or Expressionist approach to landscape painting?

a. Friedrich
b. van Ruisdael
c. Turner
d. Cézanne
e. Van Gogh

25. The artist <u>most</u> representative of the Impressionist style was:

a. Van Gogh
b. Monet
c. Manet
d. Toulouse-Lautrec
e. Munch

26. Which of the following is a court style developed as a reaction against the formality of Louis XIV and characterized by a light and delicate treatment of sensual subjects?

a. Neoclassicism
b. Rococo
c. Classical Baroque
d. Romanticism
e. Impressionism

27. The Spanish painter who most effectively combined realism and fantasy was:

 a. Velázquez
 b. Zurbarán
 c. Goya
 d. Miró
 e. Ribera

28. The sculptor who effectively combined aspects of Impressionism, Romanticism, and Expressionism in his work was:

 a. Canova
 b. Calder
 c. Maillol
 d. Rodin
 e. Lehmbruck

29. The Post-Impressionist who based his work on the color theories of Delacroix and the scientists Charles Blanc and Chevreul was:

 a. van Gogh
 b. Gauguin
 c. Cézanne
 d. Seurat
 e. Toulouse-Lautrec

30. The artist who did many self-portraits in a Surrealist style was:

 a. Géricault
 b. Kahlo
 c. Man Ray
 d. Ernst
 e. Chicago

31. The harsh, flat lighting and the juxtaposition of a nude woman with two men dressed in contemporary clothes shocked the public when Manet first exhibited his famous work entitled:

 a. *Le Déjeuner sur l'Herbe*
 b. *Le Moulin de la Galette*
 c. *A Sunday Afternoon on La Grande Jatte*
 d. *The Spirit of the Dead Watching*
 e. *The Night Café*

32. Which of the following artists was famous for the photographic process he introduced in Paris?

 a. Turner
 b. Gropius
 c. Hopper
 d. Daguerre
 e. Stieglitz

33. An important video artist is:

 a. Paik
 b. Bell
 c. Beuys
 d. Christo
 e. Shapiro

34. The landscape painter who influenced Delacroix and anticipated both the attitude and technique of Impressionism was:

 a. Turner
 b. Constable
 c. Friedrich
 d. van Ruisdael
 e. Courbet

35. A large construction of Earth Art, called *Spiral Jetty*, was designed by:

 a. Smith
 b. Hesse
 c. Hockney
 d. Abakanowicz
 e. Smithson

36. Which of the following styles best describes the work of Delacroix?

 a. Impressionist
 b. Romantic
 c. Neoclassic
 d. Realist
 e. Symbolist

37. Which of the following styles best describes the work of Canova?

 a. Impressionist
 b. Romantic
 c. Neoclassic
 d. Realist
 e. Symbolist

38. Klimt's *The Kiss* best describes the mood of the fin de siècle in Europe because of its:
 a. joyous exuberance
 b. decadence, sensuality, and opulence
 c. austerity
 d. political emphasis
 e. concern for moral values

39. Which of the following styles best describes the work of Gauguin?

 a. Impressionist
 b. Post-Impressionist
 c. Expressionist
 d. Realist
 e. Symbolist

40. Which of the following styles best describes the work of Van Gogh?

 a. Impressionist
 b. Romantic
 c. Neoclassic
 d. Post-Impressionist
 e. Symbolist

41. Which of the following styles best describes the work of Eakins?

 a. Impressionist
 b. Romantic
 c. Neoclassic
 d. Realist
 e. Symbolist

42. Which of the following styles best describes the work of Monet?

 a. Impressionist
 b. Expressionist
 c. Art Nouveau
 d. Realist
 e. Symbolist

43. The architecture of Joseph Paxton is closest in spirit to the work of:

 a. Charles Garnier
 b. Frank Lloyd Wright
 c. Gustave Eiffel
 d. Frank Gehry
 e. Borromini

44. Which of the following best describes the work of Rivera?

 a. Cubism
 b. Fauvism
 c. Surrealism
 d. Constructivism
 e. Mexican Muralist

45. Which of the following styles best describes the work of Matisse?

 a. Cubism
 b. Fauvism
 c. Surrealism
 d. Constructivism
 e. Futurism

46. Which of the following styles best describes the work of Malevich?

 a. Cubism
 b. Dada
 c. Surrealism
 d. Suprematism
 e. Abstract Expressionism

47. Which of the following styles **best describes** the work of Jackson Pollock?

 a. Cubism
 b. Fauvism
 c. Abstract Expressionism
 d. Mexican Muralist
 e. Futurism

48. Which of the following styles **best describes** the work of Lichtenstein?

 a. Cubism
 b. Dada
 c. Pop art
 d. Constructivism
 e. Abstract Expressionism

49. Which of the following styles **best describes** the work of Magritte?

 a. Cubism
 b. Dada
 c. Surrealism
 d. Constructivism
 e. Abstract Expressionism

50. The Crystal Palace, London, was **designed by**:

 a. Portman
 b. Gaudi
 c. Wright
 d. Paxton
 e. Gehry

51. The Portland Building in Oregon **was designed** by:

 a. Mies van der Rohe
 b. Gaudi
 c. Wright
 d. Paxton
 e. Graves

52. An important representative of the International Style was:

 a. Mies van der Rohe
 b. Garnier
 c. Wright
 d. Paxton
 e. Gehry

53. Pompidou Center, Paris, was designed by:

 a. Garnier
 b. Gaudi
 c. Mies van der Rohe
 d. Rogers and Piano
 e. Gehry

54. The Guggenheim Museum in Bilbao was designed by:

 a. Reitveld
 b. Le Corbusier
 c. Wright
 d. Paxton
 e. Gehry

55. The Art Nouveau staircase in the Van Eetvelde House is Brussels was designed by:

 a. Victor Horta
 b. Gaudi
 c. Mies van der Rohe
 d. Paxton
 e. Saarinen

56. Monticello in Virginia was designed by:

 a. Mies van der Rohe
 b. Gaudi
 c. Richardson
 d. Jefferson
 e. Saarinen

57. Notre-Dame-du-Haut, Ronchamp, was designed by:

a. Le Corbusier
b. Gaudi
c. Richardson
d. Paxton
e. Rogers and Piano

58. The Guaranty (Prudential) Building in Buffalo was designed by:

a. Portman
b. Gaudi
c. Richardson
d. Paxton
e. Sullivan

SHORT ANSWER QUESTIONS
Answer the question or finish the sentence.

59. Name two Surrealist artists:

60. What was the significance of the Armory show?

61. What did Gustave Eiffel, Joseph Paxton, and Louis Henry Sullivan have in common?

62. In what type of painting did Vigée-Lebrun specialize?

63. Name a Minimalist sculptor and briefly describe the style.

64. Who designed the Vietnam Memorial in Washington, D.C.?

65. Who was the leader of Neoclassicism in 19th-century France?

66. What was the political significance of Géricault's *Raft of the Medusa*?

67. Who was William Blake?

68. Name two Spanish painters who created strong paintings condemning attacks on the Spanish people:

69. What type of lighting was preferred by Joseph Wright of Derby?

70. Name the English painter famous for his satirical scenes of social criticism:

71. What was the political meaning attributed to David's *Oath of the Horatii*?

72. What was the Hudson River school? Name one artist associated with it.

73. Which artistic style created vibrant effects of light through juxtaposition of bits of pure color?

74. Name four artists who are known as Post-Impressonists:

75. What was the major significance of the materials and structural techniques used by Joseph Paxton in the Crystal Palace?

76. Identify Die Brücke.

77. How did Turner portray the horrors of the slave trade, and how did this portrayal embody Edmund Burke's definition of the sublime?

78. Who were the Futurists? Name two artists who were associated with the group.

79. What is meant by "Deconstructionist" architecture?
80. Name three 20th-century female artists who use art as a political weapon:

81. What was the political significance of Picasso's *Guernica*?

82. In what way did European Surrealism influence the American Abstract Expressionists?

IDENTIFICATION

83. Attribute the sculpture below to an artist, country, and a quarter century. Give the reasons for your attribution.

Artist:

Country:

Date:

Reason:

84. Compare the two sculptural groups below, attributing each to an artist, country, approximate date, and style. Give the reasons for your attributions.

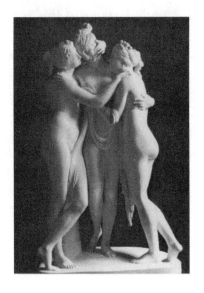

A. Artist

 Country:

 Decade:

 Reason:

B. Artist

 Country:

 Decade:

 Reason:

85. Compare the two abstractions **below, attributing** each to an artist and approximate date. Give the **reasons for your** attributions.

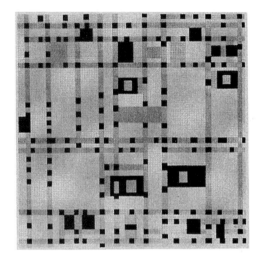

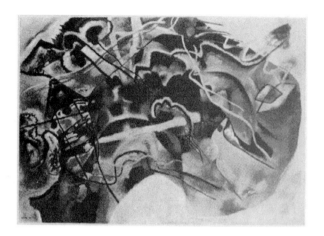

A. Artist

Country:

Decade:

Reason:

B. Artist

Country:

Decade:

Reason:

86. Compare the two landscapes below, attributing each to an artist and approximate date. Give the reasons for your attributions

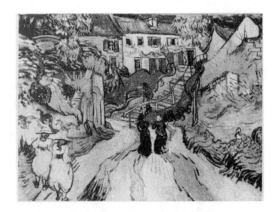

A. Artist

Date:

Reason:

B. Artist

Date:

Reason:

87. What is depicted in the painting reproduced below? Attribute it to an artist, a style or stylistic movement, and a quarter century. Give the reasons for your attributions. What do you think was the major concern of the artist?

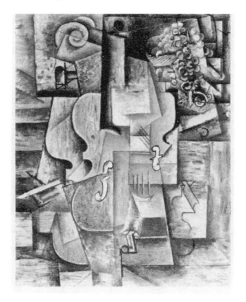

Subject:

Artist:

Style:

Date:

Reason:

ESSAYS

Select one essay, and be sure to cite specific examples to illustrate your argument.

A. Discuss the development of painting in America in the second half of the 20th century. What did it adopt from European avant-garde artists, and what was uniquely American?

B. Compare 20th-century International Style architecture with so-called "deconstructivist" architecture. What are the basic principles of each, and how do they differ?

C. Discuss the development of Neoclassicism and Romanticism in Europe in the 18th and 19th centuries. What characteristics can be identified with each style? Discuss specific works that illustrate these characteristics.

QUIZ ANSWERS
THE MODERN WORLD

MULTIPLE CHOICE

1. d	11. b	21. a	31. a	41. d	51. e
2. c	12. c	22. e	32. b	42. a	52. e
3. c	13. a	23. c	33. a	43. e	53. c
4. c	14. b	24. d	34. a	44. e	54. d
5. d	15. b	25. b	35. a	45. d	55. e
6. c	16. d	26. b	36. b	46. d	56. a
7. c	17. d	27. c	37. c	47. c	57. d
8. b	18. b	28. d	38. e	48. c	58. d
9. a	19. c	29. d	39. c	49. c	59. a
10.c	20. c	30. b	40. b	50. d	60. c

SHORT ANSWERS

61. two from Dali, Magritte, Ernst, and Miro.

62. The Armory show introduced America to avant-garde European art.

63. all three were eighteenth-century British architects.

64. portraiture

65. Tony Smith and Donald Judd (Maya Lin could be considered a Minimalist as well). They created three-dimensional objects, often in primary geometric forms, that often lack identifiable subjects, colors, surface textures and narrative elements.

66. Maya Lin

67. Ingres

68. Géricault's *Raft of the Medusa* was critical of the government in that it portrayed an incident in which the crew of a passenger ship abandoned the passengers after a wreck, leaving them to fend for themselves.

69. an eighteenth-century British visionary poet and painter.

70. David, Canova, Gros, and Vignon

71. dramatic lighting resembling Caravaggio's tenebroso, often produced by candlelight or moonlight.

72. Hogarth

73. It was considered a call to arms and a call to sacrifice for the republic as the Horatii had done.

74. A group of nineteenth-century American landscape painters who worked in the eastern United States along the Hudson river. Thomas Cole was one of them.

75. Impressionism (or Pointillism)

76. Cezanne, Seurat, Van Gogh, Gauguin, or Toulouse-Lautrec

77. Paxton used structural elements honestly for what they were and did not give them revival-style decoration. In addition, he used prefabricated parts that allowed rapid construction. His iron supports were steps on the way to twentieth-century skyscraper construction.

78. Oldenburg

79. The Bauhus, founded in 1919, was dedicated to training artists, designers, and architects to meet twentieth century needs. The teachers at the Bauhaus made no distinction between artists and craftsmen. They stressed simplicity and elegance as well as functional design, and influenced twentieth century design world-wide. Gropius and later Mies van der Rohe served as director, and among the artists and designers who taught there were Moholy-Nagy, Kandinsky, Klee, Albers, Breuer and Stolzl.

80. Deconstructionist architects attempt to disorient observers by disrupting conventional categories of architecture using haphazard mixture of forms.

81. Any three from Judy Chicago, Miriam Schapiro, Cindy Sherman, Barbara KrugerAna Mendieta, Hannah Wilke, Kiki Smith, Faith Ringold, Adrian Piper, Lorna Simpson or the Gorrilla Girls.

82. Picasso portrayed the horrors of the bombing of the small Spanish town of Guernica by the Nazis at the beginning of the Spanish Civil War.

83. Any three from Beckmann, Grosz, Gropius, Moholy Nagy, Albers, Breuer, Mies van der Rohe, Ernst, Dali, Leger or Lipchitz.

IMAGES MULTIPLE CHOICE

84. c	90. c	96. b	102. b	108. b	114. b
85. c	91. b	97. a	103. c	109. d	115. a
86. c	92. a	98. b	104. b	110. b	116. c
87. d	93. a	99. c	105. a	111. b	
88. a	94. b	100. d	106. d	112. d	
89. b	95. a	101. c	107. a	113. b	

IMAGE FILL-IN

117. Rococo

118. Cassatt

119. Tanner

120. Wright

121. United States

122. Gaudi

123. Spain

124. Art Nouveau

125. Daumier

126. Daumier's Third Class Carriage **was illustrating** the trains that became popular in the mid 19th century. He **is showing the** poor of the city.

127. David

128. The crowning of Napoleon, or **rather Napoleon** crowning Josephine

129. Delacoix

130. Liberty Leading the People, **illustrating the** uprising of the Parisians against Charles X in 1830.

131. Paris, 19th century.

132. Gauguin

133. The Vision after the Sermon, or a symbolic scene in Brittany.

134. The primary influences from Japanese prints are the flattening of the image, the abrupt juxtaposition of foreground and background, and the patterning seen in the hats of the women.

135. Watteau

136. France, 18th century

137. Rococo

138. Seurat

139. France, 19th century

140. Pointillism

141. Seurat placed small dots, or points, of color on the canvas which were mixed by the eye. His technique was based on scientific theories.

IDENTIFICATIONS WITH ESSAY

142. Boyle and Kent

143. England, 18th century

144. Palladian (or Neoclassic)

145. Neumann

146. Germany, 18th century

147. Rococo (or Late Baroque)

148. These two buildings, Chiswick House and Vierzehnheiligen, illustrate the stylistic poles of 18th century architecture. The centralized structure and classical details of Chiswick House recall the works of the 16th century Italian architect Palladio whose so-called 'Palladian' style was popular in England and America. The purity of Chiswick House with its straight lines and simple planes is in sharp contrast to the complexity of Vierzehnheiligen with its interlocking ovals and rich decoration. One sees echoes of the Italian Baroque forms of Borromini but with the addition of delicate and complicated forms of the Rococo style.

149. Rodin

150. France

151. Canova

152. Neoclassic

153.　A.　Rodin, France, late nineteenth to early twentieth century (*Three Fates from the Gate of Hell*, 1880-1917. Musée Rodin, Paris.)

　B. Canova, Italy or France, early nineteenth century, Neoclassicism (*Three Graces*, 1814. Ny Carlsburg Glyptych, Copenhagen.)

These two sculptured groups demonstrate the difference between Canova's cool and formal Neoclassicism and Rodin's much more emotional style, which combines elements from Romanticism, Impressionism, and an expressive Realism. Rodin's figures are cast in bronze from clay models, and his use of soft clay enabled him to create subtle variations and shifts of the places under the play of light and thus to achieve effects that were impossible to an artist like Canova, who carved directly into marble. Rodin's fluid modeling is analogous to the deft Impressionist brush stroke, but the exaggerations of the forms and the striking gestures of the three figures as they point downward echo the dramatic intensity of Romantic and Expressionist works. The impression of work in-progress created by the figures seems to derive from the unfinished works of Michelangelo, which influenced Rodin deeply. Rodin's concern with dramatic statement and with expressive bodily pose and gesture shows clearly the influence of Michelangelo.

Canova's graceful female figures derive from very different sources. There is a lingering Rococo charm, but the precise technique used to create the idealized figures, which combine careful detailing and generalized forms, is clearly in the Classical tradition. These three figures are closely related to Coanova's representation of Pauline Borghese as Venus, for they demonstrate the same type of femininity" ideal and seemingly distant, yet human and accessible at the same time.

154. Cezanne

155. Van Gogh

156. France, 19th century

157.	A. Cézanne, late nineteenth century (*The Gulf of Marseilles Seen from L'Estaque*, 1884-1886. Metropolitan Museum of Art, New York.)

B. Van Gogh, late nineteenth century (*Mountain Landscape with Rising Sun*, 1889. Amsterdam, Van Gogh Museum.)

These two paintings, done in late nineteenth-century France by two Post-Impressionists, show the same contrast in approach that we see in the twentieth century between Mondrian and Kandinsky. Van Gogh's approach to the painting is instinctive and emotional, while Cézanne's is deliberate and intellectual. The van Gogh landscape shows the same type of strong, impulsive brush strokes that he used in *Starry Night*. There are no stable forms; rather everything seems to be in motion. Unfortunately, the black-and-white reproduction does not show the intense color that van Gogh loved and made such an important part of his painterly expression.

Color was important to Cézanne too, but he used it to build up form and pictorial structure and not to express emotional states as did van Gogh. The carefully interlocked planes he developed in his painting of Mont. Sainte-Victoire are also used here and interlock forcibly on the two-dimensional surface of the canvas. As in his other landscapes, he has immobilized the shifting colors of Impressionism and has created a series of clearly defined places. This is a much more stable-looking landscape than the one created by van Gogh. Like Mondrian, Cézanne has achieved this stability by emphasizing vertical and horizontal lines in his composition, while van Gogh, like Delacroix and Kandinsky, has created an emotional and constantly changing effect in his by using diagonal lines that undulate. The landscape with its uptilted ground seems almost to be sliding off the canvas.

ESSAYS:
Answers found throughout the text.

PREPARING FOR YOUR EXAMINATIONS

As you prepare to take your examination you should review the notes you took on your lectures as well as the work you did in your Study Guide. (Look back at the **Introduction to the Study Guide** for tips on taking notes and creating your own charts, as well as detailed instructions on studying for and taking examinations.) If you have not yet filled out the Summary charts in the Guide, this is the time to do it, integrating materials from your lecture notes with materials in the Guide itself. This activity is the most useful thing that you can do.

The self-quiz included below, as well as the materials included in the **Companion Site** for the textbook, can be a great help in preparing you for course examinations. The questions are modeled on those commonly asked on art history examinations: multiple choice, short answer questions, chronology exercises, essay questions and attribution of unknown images. Take the self-quiz and check your answers in the back of the book; see how well you grasp the material. If you are unclear about certain areas review the text and utilize the on-line Web Site and WebTutor tools to fill in the gaps. You may also wish to consult the WorldImages website which contains many art historical images and is the source of the images used in the quiz below. See http://worldimages.sjsu.edu. Note particularly the Art History survey section.

Self-Quiz
GLOBAL ART: INDIA & SOUTHEAST ASIA, CHINA & KOREA, JAPAN, THE AMERICAS, OCEANIA AND AFRICA

CHAPTERS 26, 27, 28, 32, 33, 34

MULTIPLE CHOICE
Circle the most appropriate answer.

1. A gopura would be found in connection with A:

 a. Hindu temple b. Chinese pagoda
 c. Benin shrine d. palace of a Japanese emperor

2. Identify the Mughal emperor who was a patron of the arts:

 a. Krishna b. Schwedagon c. Jahangir d. Sukhotai

3. The San people would be found in:

 a. Mesoamerica b. Micronesia c. Polynesia d. South Africa

4. Veneration of ancestors was an important part of the religious rituals of the:
 a. Dogon b. Benin c. Moiri d. all of the above

5. The war god Kuka'ilimoku was worshipped in

 a. Hawaii b. Micronesia c. the Kongo d. Japan

6. Which of the following was *NOT* a Pre-Columbian group from South America
 or Mesoamerica?

 a. Aztec b. Mixteca c. Inka d. Haniwa

7. An important Chinese painter was:

 a. Sesshu b. Manitoba c. Wu Zhen d. Genji

8. Tlingit and Kwakiutl masks would most likely be found in:

 a. Mexico b. Northwest United States and British Columbia
 c. Micronesia d. Southwest United States

9. The so-called Forbidden City was located:

 a. near Sanchi in Northwest India b. on the island of Honshu in Japan
 c. in Beijing, China d. high in the Andes Mountains in Peru

10. Which of the following groups is *NOT* found in Africa?

 a. Dogon b. Baga c. Trobriand d. Senufo

11. Large mysterious statues known as *moai* were found in:

 a. Belau (Pilau) b. New Guinae c. Easter Island d. Hawaii

12. Which LEAST characteristic of **Hopi Katsina** figures?

 a. were personified and danced **in yearly festi**vals
 b. evil spirits who did harm to **children**
 c. personified natural elements
 d. lived in mountains and water **sources**

13. Which is *NOT* true about Japanese **woodblock** prints:

 a. always very rare
 b. illustrated sensual world and **entertainment**
 c. often have black outlines sepa**rating solid** colors
 d. known as ukiyo-e

14. Which of the following was *NOT* **commonly** included in a Benin Royal Ancestor shrine?

 a. Elephant tusk b. Portrait **of King's** Head
 c. Royal skulls d. Rattle **Staffs**

15. Asmat bijs poles of New Guinea :

 a. served as a pledge to avenge a **relative's** death
 b. commemorated an ancestor **who would** protect the house
 c. marked the house of the high **chief**
 d. marked the place where women **gathered** for fertility rituals

16. Which of the following marks of **female beauty** was *NOT* included in a Mende mask ?

 a. High broad forehead b. **Intricately** plaited hair
 c. Protruding ears d. **Small closed** mouth

17. Tattoos were extremely popular :

 a. with the upper class among **the Inka** b. in Polynesia
 c. in Ming China d. with the Japanese samuri

18. Which best describes the Aztec **figure** of Coatlicue?
 a. massive b. **decorated** with skulls and snakes
 c. covered with feathers d. **a and b**

19. Which of the following applies to the work of Sesshu?

 a. dripped ink onto paper b. extensive use of gold
 c. detailed textile patterns d. b and c

20. The "literati" painters worked in

 a. India b. China c. Japan d. South East Asia

21. The artist best known for his woodblock prints was:

 a. Toyo Sesshu b. Katsushika Hokusai
 c. Kano Eitok d. Kano Moronobu

22. For what was Maria Martinez famous?

 a. Weaving b. Woodcuts c. Ceramics e. Ledger painting

23. The Vietnamese are most famous for:

 a. tiny ivory sculptures b. manuscripts made of palm leaves
 c. ceramics d. embroidered silk fabrics

24. The love between Krishna and Radha symbolized:

 a. the model of the devotion owed to Vishnu
 b. the Christian missionaries' image of the love of Christ for his church
 c. a moralistic warning against sexual relations
 d. the virgins that would be awaiting a martyr

25. Which is least typical of Buddha figures from Sukhotai ?

 a. are often of the Walking Buddha type
 b. have a flame coming from the top of the head
 c. have a graceful curvilinear pose
 d. have four sets of arms

26. The "X-ray" style of Auuenau painting was found in:

 a. Australia b. Hawaii c. Melanesia d. South East Asia

27. Guiseppe Catiglione was

 a. an artist who worked in China
 b. a collector of Mughal manuscripts
 b. a missionary to Japan
 c. famous for his portraits of Native Americans

28. Song Su-Nam can be identified as a:

 a. contemporary Nigerian artist
 b. Chinese painter of the Ming period
 c. contemporary Korean artist
 d. 19th century woodblock cutter

29. Bester's *Homage to Steve Biko* refers to:

 a. a Micronesian "storyboard"
 b. a martyred South African leader
 c. the arrival of the missionaries in Hawaii
 d. a martyr in the Indian struggle against the British

30. Which best describes African Nail Figures (nkisi n'kondi) ?

 a. embodied spirts who could heal or inflict harm
 b. bristle with nails and blades
 c. must be activated with a ceremony
 d. a, b and c all relate to the figures

MATCHING
Choose the identification in the right column that best corresponds to the term or name in the left column and write the appropriate letter in the space provided.

_____ 31. Chilkat blanket a. pillared hall of a Hindu temple

_____ 32. Ledger paintings b. device for record keeping

_____ 33. Mandapa c. manifestation of a Hindu God

_____ 34. Krishna d. made in NW America & British Columbia

_____ 35. Edo e. "Pictures of a floating world"

_____36. Quipu

f. made by Native Americans from the Plains

_____37. Muromachi

g. a magical, geometric symbol of the cosmos

_____38. Ukiyo-e

h. period in China under the Mongols

_____39. Yuan

i. old name for Tokyo

_____40. Moctezuma

j. cultural group from New Mexico

_____41. Inka

k. Japanese stylistic period

_____42. Kano school

l. Aztec ruler

_____43. Zen

m. Mughal ruler

_____44. Akbar

n. Hindu rulers

_____45. Rajput

o. Japanese painters

p. Japanese Buddhism sect

q. Pre-Columbian group in Peru

GEOGRAPHIC EXERCISE
Indicate the country where each of the buildings or art works is found.

	Location
46. Emerald Buddha	_____
47. Taj Mahal	_____
48. Mach Picchu	_____
49. Katsura Imperial Villa	_____
50. Tenochtitlan	_____
51. Forbidden City	_____

52. Schwedagon Pagoda _____

53. Nandaemun Gate, Choson _____

54. Mbari house _____

55. Kenzo's Olympic Stadium _____

SHORT ANSWER QUESTIONS
Answer the question or finish the sentence.

56. What is the predominant religion in Thailand and Myanmar (Burma)?

57. To what does the term Mughal refer?

58. In what current-day country in South America was Pre-Columbian art most highly developed?

59. What virtue was particularly encouraged by the Japanese tea ceremony?

60. Name two Chinese painters from the Ming dynasty.

61. What are some of the functions of masqueraders in African society?

62. What type of work does the African sculptor Kane Kwei create?

63. What is the function of the "storyboards" depicted on the men's ceremonial houses in Belau?

64. The Japanese artist Hamada Shoji is best know for:

65. Briefly describe a traditional Chinese garden:

66. For what characteristics is Inka architecture most famous?

67. What was the purpose of Navajo sand or "dry painting"?

68. What did bamboo symbolize for Chinese artists?

69. In what country did the Chosen Dynasty rule?

70. Who was Olowe of Ise?

IMAGES MULTIPLE CHOICE

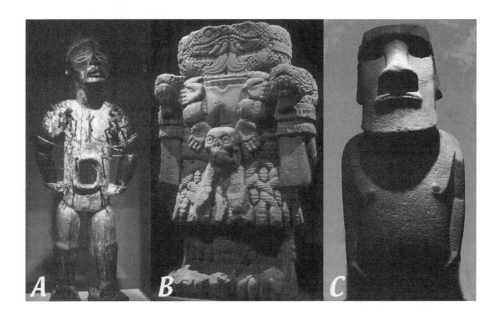

71. From what cultural area does the work in image A come?

 a. Mesoamerica b. Africa c. South East Asia d. Oceania

72. What description best fits the work shown in image A?

 a. moai b. power figure c. ancestor figure d. portrait of a chief

73. From what cultural area does the work in image B come?

 a. Mesoamerica b. Africa c. South East Asia d. Oceania

74. What is the title or subject of the work shown in image B?

 a. Quetzalcoatl b. Coatlicue c. Cuzco d. Katsina

75. From what cultural area does the work in image C come?

 a. Mesoamerica b. Africa c. South East Asia d. Oceania

76. What term best fits the work shown in image C?

 a. moai b. power figure c. curing image d. mallagan

77. From what country does the work shown in image A above come?

 a. Myanmar (Burma) b. China c. India d. Thailand

78. From what cultural area do the two works above shown in B and C come?

 a. China b. Africa c. South East Asia d. Japan

79. What is the purpose of the objects shown in image B above?

 a. shaving instruments b. objects used in a sacrificial ceremony
 c. cooking vessels d. objects used in the tea ceremony

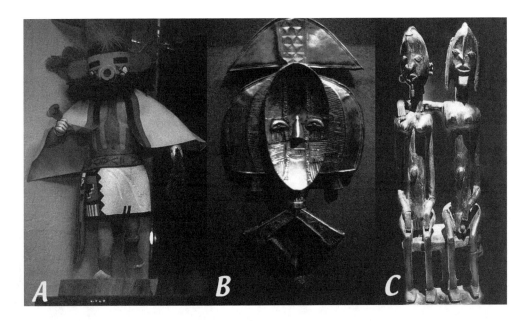

80. From what cultural area does the work shown in image A above come?

 a. Mesoamerica b. Southwestern United States
 c. South East Asia d. Oceania

81. What term best fits the work shown above in Image A?

 a. Katsina figure b. Power figure c. mallagan d. ukiyo-e

82. From what cultural area does the work above in image B come?

 a. Mesoamerica b. Africa c. South East Asia d. Oceania

83. What is the purpose of the object shown in image B above?

 a. guardian of ancestor reliquary b. object used in a sacrificial ceremony
 c. used to mark the throne of a king d. used in the fertility ceremony

84. From what cultural area does the work in image C come?

 a. Mesoamerica b. Africa c. South East Asia d. Oceania

85. What term best fits the work shown in image C?

 a. ancestor figures b. power figures c. curing images d. mallagan

IMAGES WITH FILL-INS

Write in the word that answers the question or completes the sentence.

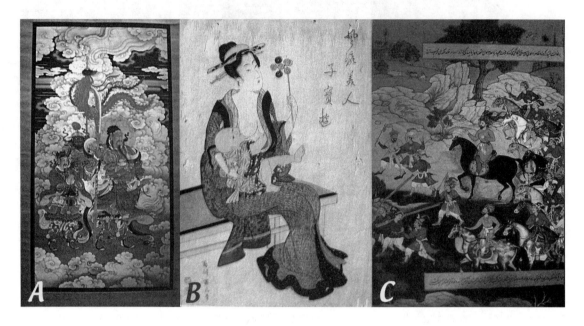

86. Name the country were the painting shown in image A above was made:

87. Name the country were the painting shown in image B above was made:

88. Name the country were the painting shown in image B above was made:

89. Which of the images above could be termed ukiyo-e?

90. Which of the images above could be termed Mughal?

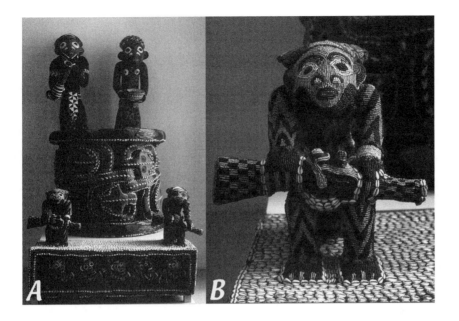

91. Image B above is a detail of image A. What was the function of the work?

92. Name two materials that were used to create it:

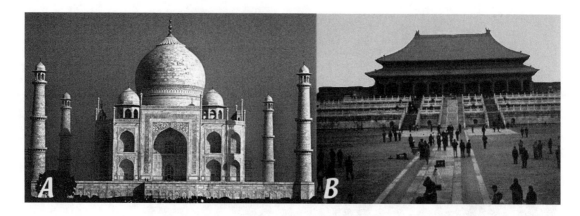

93. In what country was the building shown above in image A constructed?

94. What is its name?

95. What was the purpose of the building?

96. In what country was the building shown above in image B constructed?

97. What complex was it a part of?

98. In what cultural area were the objects in image A above created?

99. What was their purpose?

100. In what cultural area were the objects in image B above created?

101. What is the name of the style used to create them?

102. In what cultural area was the blanket in image C above created?

103. Name two stylistic features that occur in the design of the blanket that are typical of the region:

104. In what country was the painting shown above created?

105. What do you think is the subject of the painting?

106. In what country was the painting shown above created?

107. What do you think is the subject of the painting?

108. What is the term given to the writing shown in the upper right of image A?

IMAGE IDENTIFICATION WITH ESSAYS

109. In what cultural area was the object in image A above created?

110. In what cultural area was the object in image B above created?

111. Write a short essay comparing the two images, noting particularly their styles, materials and their purposes.

112. In what country was the art work shown above in image A created?

113. What was its medium?

114. In what country was the art work shown above in image B created?

115. What was its medium?

116. What century was it done?

117. Write a short essay comparing the two images, noting particularly their styles, their materials and the emotional effect each creates.

ESSAYS

Select one essay, and be sure and cite specific examples to illustrate your argument.

1. Select four groups and discuss their use of masks. How were they constructed and what role did they play in the social structure,

2. Discuss the development of painting and graphics in Japan from the 16th century to the present. What features were influenced by the art of China and the west and what features were indigenous?

3. In what ways did the art of Japan influence the art of the west? Think about things you have seen reproduced and also things that are around you. Be sure and cite specific examples to illustrate your argument.

4. This is an open book essay. Discuss the contemporary art that you have seen in the text from Japan, China, Africa and Oceania noting the influences of their traditional arts and influences from the west. Compare it with art of the west shown in chapters 31 and 35, and note influences on contemporary western art that derive from the non-western cultures you have studied.

QUIZ ANSWERS
GLOBAL ART: INDIA & SOUTHEAST ASIA, CHINA & KOREA, JAPAN, THE AMERICAS, OCEANIA AND AFRICA

MULTIPLE CHOICE & MATCHING

1. a	9. c	17. b	25. d	33. a	41. q
2. c	10. c	18. d	26. a	34. c	42. o
3. d	11. c	19. a	27. a	35. i	43. p
4. d	12. b	20. b	28. c	36. b	44. m
5. a	13. a	21. b	29. b	37. k	45. n
6. d	14. d	22. c	30. d	38. e	
7. a	15. b	23. c	31. d	39. h	
8. b	16. c	24. a	32. f	40. l	

GEOGRAPHIC EXERCISE & SHORT ANSWER QUESTIONS

46. Thailand

47. India

48. Peru

49. Japan

50. Mexico

51. China

52. Burma (Mayanmar)

53. Korea

54. Africa

55. Japan

56. Buddhism

57. The name given to the Muslim dynasty in India which means "descended from the Mongols."

58. Peru.

59. Humility was a goal of the tea ceremony

60. Shang Xi, Shen Zhou or Dong Qichang.

61. Dancers dressed in masquerade costumes and masks perform a numbr of function such as dramatizing creation legends, encouraging fertility of the land and the people, and helping with initiation and other rituals in both men's and women's societies. They also serve governing and judicial functions and act as mediators between members of the village and the spirits of ancestors.

62. Kwei creates coffins in many creative shapes.

63. Storyboards told the history and myths associated with the builders of the men's house.

64. Ceramics

65. Chinese gardens attempted to create a natural environment, and contained plants, water features, winding paths and usually contained strangely-shaped rocks that echoed shapes of nature. They are totally different from formal French gardens which emphasized geometric shapes.

66. Huge beautifully fitted masonry blocks.

67. Navajo sand or "dry paintings" were created as part of healing ceremonies.

68. The ability to bend in the face of adversity but does not break.

69. Korea.

70. A Yoruba sculptor of the late 19th and early 20th centuries.

71. b	74. a	77. b	80. b	83. a
72. b	75. d	78. d	81. a	84. b
73. a	76. a	79. d	82. b	85. a

86. China

87. Japan

88. India

89. B

90. C

91. It served as a throne or stool and a footstool for the king. The figure in image B served as a guardian.

92. Beads and cowery shells.

93. India

94. Taj Mahal

95. It served as a mausoleum for the wife of the ruler.

96. China

97. The Forbidden City n Beijing.

98. Oceania

99. The Asmat poles served as a pledge to avenge a relative's death.

100. Oceania (Australia)

101. X-ray.

102. The Chilkit blanket was made in the Northwest coast of America.

103. symmetry and rhythmic repetition and schematic abstraction of animal motifs.

104. India

105. The image shows lovers in a garden. They represents Krishna and Radha who symbolize the love of the devote for the god.

106. China

107. It shows a man walking across a stone bridge, which probably represents a a scholar retreating to the wilderness.

108. Calligraphy is used to write the inscription in the upper part of the painting, which is most likely a poem.

109. Africa

110. Oceania

111. Both of these masks were used in ceremonies, image A in a Mende women's society, and image B in a New Ireland melanggan ceremony. The Mende mask is carved of wood which is painted black and decorated with raffia which covers the dancer's face. The features of the mask—elaborate headdress, dainty triangular faces, and roles of fat around the neck-- represent ideal women of the group, and are used in ceremonies initiating girls into womanhood.

The Tatanuan mask is much more frightening image which reflects its use in ceremonies which help the soul make the transition from the life of the living to the realm of the dead. The masks are made of soft wood, fiber and shells and are painted with colors of black, white, yellow and red, colors that are associated with warfare and violence.

112. China

113. Painting, ink on paper

114. Japan

115. Woodcut or woodblock print.

116. 19th century

117.
A. Chinese. Qing Dynasty (Lin Yu. Landscapes Inspired by Tang Poems. Page from an album. 1689. Ink on paper. Washington D.C. Smithsonian Institution.

B. Japan, Edo or Tokugawa period, nineteenth century (Hokusai, *The Great Wave of Kanagawa* from *Thirty-six Views of Mt. Fuji*, c. 1826-1833. Woodblock print. Boston, Museum of Fine Arts)

Landscapes were very important for Chinese artists of theMing and Qing periods, whether done as hanging scrolls or as album pages, which is the case here. Artists ost often were inspired by artists of earlier periods as was the case here, and many had a close affinity with poetry. One can see the calligraphy in the upper left hand corner that records the Tang poem that inspired the artist. You don't need to know the period of the poem, but you should have observed the calligraphy, and speculated about what it might have recorded). The small pavilion in the painting illustrates the common Chinese love of showing human beings and their creations as very small in the vastness of nature.

The boldness and strength of this woodblock print is unlike anything produced in China. The bold lines and patterns of this wood block print reflects Hokusai's grand and monumental view of nature and dynamic asymmetrical composition. Here too, human being are small in the face of nature, but in the woodcut the juxtaposition is violent with the small boats threatened by the huge waves, not calm and peaceful as one finds in the Chinese painting.

ESSAYS
Answers can be found throughout the text.